WARRIORS OF ART

WARRIORS

OF ART

A Guide to Contemporary
Japanese Artists

Yumi Yamaguchi

TRANSLATED BY Arthur Tanaka

KODANSHA INTERNATIONAL
Tokyo • New York • London

Endpaper illustration *Speech Balloon Man: Dance* (detail) by Kengo Nakamura. Courtesy Kengo Nakamura.

Distributed in the United States by Kodansha America Inc., and in the United Kingdom and Continental Europe by Kodansha Europe Ltd.

Published by Kodansha International Ltd., 17–14 Otowa 1-chome, Bunkyo-ku, Tokyo 112–8625, and Kodansha America Inc.

First edition, 2007
16 15 14 13 12 11 10 09 08 07 10 9 8 7 6 5 4 3 2 1

Library of Congress Cataloging-in-Publication Data

Yamaguchi, Yumi.
 Warriors of art : a guide to contemporary Japanese artists / Yumi Yamaguchi ; translated by Arthur Tanaka.-- 1st ed.
 p. cm.
 ISBN-13: 978-4-7700-3031-3
 ISBN-10: 4-7700-3031-2
 1. Art, Japanese--20th century. 2. Artists--Japan--20th century.
 3. Art, Japanese--21st century. 4. Artists--Japan--21st century. I. Title.
 N7355.Y355 2007
 709.2'2--dc22

 2006030601

www.kodansha-intl.com

CONTENTS

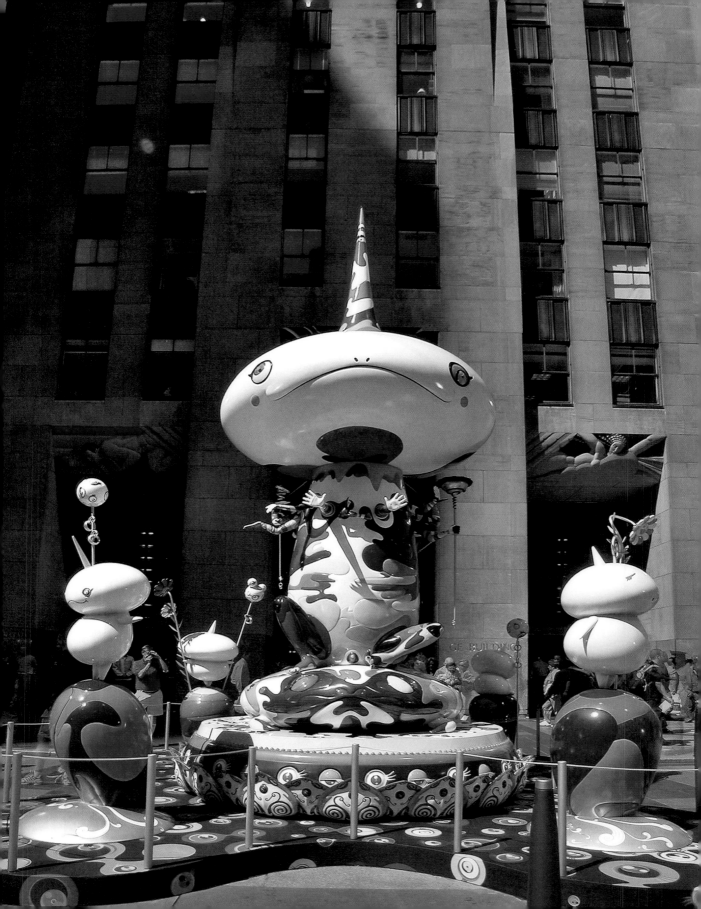

Introduction

In 2006, the United States section of the International Association of Art Critics gave their award for Best Thematic Museum Show in New York City to Takashi Murakami's 2005 exhibition, Little Boy: The Arts of Japan's Exploding Subculture. This was an indication not only of a growing awareness and appreciation overseas of Japan's visual culture, but also an acknowledgment of the relevance of Murakami's groundbreaking mix of subculture, pop culture, and fine art. Regarded by many as the most influential contemporary artist to come out of Japan, Murakami in turn pays tribute in his *Little Boy* catalog to pioneering painter and sculptor Taro Okamoto (1911–1996) who, as an art student in France in the 1930s, was influenced strongly by vanguard groups such as Abstraction-Création and the surrealists. On his return to Japan, Okamoto struggled to gain acceptance for the ideas he had learned in France, and he also went to great lengths to bring art to a more popular audience, even going as far as appearing in variety shows and slapstick comedies on TV. Like Murakami, Okamoto battled the status quo of the art world, and for this, Murakami's *Little Boy* catalog dubs him "a rare 'warrior of art' in postwar Japan." [1]

Today, Murakami is at the forefront of a new generation of warriors, who challenge our preconceived ideas about art, and force us to sit up and take notice of what they have to say. The forty contemporary artists featured in this book range from painters and sculptors to photographers and performance artists. They range from artists who have already made an impact on overseas audiences to exciting new talents on the Japanese scene. They range from those working with the latest digital technologies to those who use traditional materials and methods that date back hundreds of years. What all these artists have in common is that they are a product of contemporary Japan.

Takashi Murakami, *Reversed Double Helix*, 2003. Urethane paint, fiberglass, and steel.

Japan—exporter of cool pop culture in the field of manga.

Junko Mizuno, *Nurse Ruriko and Nurse Masako* from the manga *Pure Trance*. 1998. Pen on paper.

Japan—exporter of cool pop culture in the fields of manga, anime, film, fashion, literature, art, architecture, and design—has become *the* yearned-for country amongst the younger generation of Asians, Europeans, and Americans. But for the longest time Japan was an "informational black hole," receiving messages from the outside world but failing to transmit anything back. After three hundred years of isolation during the Edo period (1603–1868), when all contact with other countries was forbidden, Japan was finally forced to open its frontiers in 1868, and Western culture, art, and technology flooded in. Japan eagerly absorbed and adapted these new ideas, but after such a long history of isolation, the country seemed to lack confidence that its own home-produced culture would be appreciated overseas.

It was only in the 1980s that Japanese contemporary artists started to make a sustained impact on the world stage, although this was not the first time that Japanese artists had exhibited overseas. Taro Okamoto took part in the International Surrealist Exhibition in Paris in 1938, and both he and *nihonga* painter Taikan Yokoyama exhibited at the Venice Biennale in the 1950s. Avant-garde artist Yayoi Kusama moved to New York in the late 1950s, and in the 1960s Yoko Ono became active in the Fluxus movement in the United States. Other Japanese artists who have chosen to live and work in America include On Kawara, Hiroshi Sugimoto, and, more recently, Mariko Mori. But the 1980s was a turning point for Japanese art. First came the Avant-Garde in Japan exhibition in Paris in 1986. Then, at the Venice Biennale Aperto exhibition in 1988, young Japanese artists Tatsuo Miyajima and Yasumasa Morimura made their international debut to widespread critical acclaim. They appeared again in the exhibition Against Nature: Japanese Art in the Eighties that toured the United States in 1989, and were perhaps the first Japanese contemporary artists to join art's international major league without actually having to move overseas.

It was against this historical background that in 2001 Takashi Murakami took his self-curated Superflat exhibition on a tour of US cities, armed with a bilingual catalog expounding his own impassioned "superflat" theory. In this exhibition, which featured the paintings of sixteenth-century woodblock artists alongside the works of animators Koji Morimoto and Yoshinori Kanada, manga artist Henmaru Machino, designer 20471120, photographers Masafumi Sanai and Hiromix, and contemporary artists Yoshitomo Nara and Katsuhige Nakahashi, Murakami presented his concept that all creative works on a flat surface are "hyper two-dimensional" or "superflat," and that the term superflat can also be used to describe the shallow emptiness of Japanese consumer culture.

Murakami had already revealed the key notions supporting the superflat concept in a 1999 article published in the magazine *Kokoku hihyo*. He argued that since Japan's defeat in the Second World War, Japan had been like a child, under the control of its father, America, and this had created a childish, irresponsible society with "1) a value system built on an infantile sensibility, 2) a society without any definitive standard of wealth, and 3) amateurism."[2] These three negative factors, however, he argued, were bringing about new forms of creativity and artistic expression.

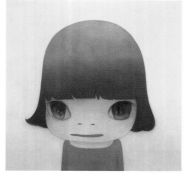

Yoshitomo Nara took part in Murakami's Superflat exhibition.

Yoshitomo Nara, *Agent Orange*, 2006. Acrylic on canvas, 64 x 64 in.

Yasumasa Morimura was one of the first Japanese contemporary artists to join art's international major league.

Yasumasa Morimura, *A Requiem: MISHIMA, 1970.11.25–2006.4.6.* C-type print, 59 x 47 in.

The themes stated here were reiterated in the second exhibition of the Superflat series, Coloriage, that opened at the Cartier Foundation for Contemporary Art in Paris in 2002, and with the third and final exhibition in the series, Little Boy. Like the preceding exhibitions, Little Boy emphasized the importance of otaku subculture—an obsession with the fantasy worlds of anime, manga, and computer games—in contemporary Japanese art. In his book *Geijutsu kigyoron* (On Starting an Arts Business) Murakami writes:

"Little Boy, the final in my trilogy of exhibitions showcasing otaku culture, was my opportunity to tell people about the country that gave birth to the *Pokémon* show their children watch. Japan has wandered a long path since the atomic bomb and defeat in the war to arrive at this culture. The atomic bomb has created a trauma in the Japanese psyche. Japan has become America's puppet, unable to make autonomous decisions about war or the state. But in exchange for autonomy, the Americans have given us peace. I wanted the West to know the singular, indisputable fact that otaku subculture necessarily *is* art in Japan."[3]

With his Superflat series, Takashi Murakami strategically set out to translate the postwar popular culture of Japan, and in doing so, he has created a foundation for Japanese contemporary art to be understood by the West.

Equally influential in recent years is Yoshitomo Nara, whose depictions of cute yet menacing children have made a huge impact both in Japan and overseas. His appeal lies not only in his distinctive style, but in the fact that he has collaborated across various artistic genres, designing cover art for the band Shonen Knife and for writer Banana Yoshimoto for example, and thus reaching out beyond the boundaries of art to fans of music and literature.

In 2003 Nara began his A to Z exhibition series with the team from Osaka-based creative unit "graf," where the art was housed in a series of huts created by volunteers, and each hut was for sale as a work of art. The exhibition toured New York, Bangkok, and Seoul, before culminating in 2006 in Nara's hometown of Hirosaki in Aomori Prefecture in northern Japan. The exhibition was mounted without any help from government or funding bodies, art museums or galleries, corporations or collectors, and it seems Nara has attracted the attention of curators around the world as much for his revolutionary concept in exhibitions as for his artwork.

A glance at the work of the forty artists introduced in this book reveals recurring images of the cute, the grotesque, the erotic, the violent. Japan is a society where the dividing lines between adult and child culture are blurred: where the sharp-suited salaryman with his brand name briefcase wears a Winnie-the-Pooh watchstrap, where plastic toys given away as free gifts with food items line the desk of the young bureaucrat. It is a society where expressions of sexuality and violence flood the marketplace, particularly in the magazines, sports newspapers, and manga that spill from convenience store shelves into the hands of subway commuters. In the West, this sort of explicit content divides adult and child media, but there is no such division in Japan, where the West's Judeo-Christian taboos do not exist. Children's manga and

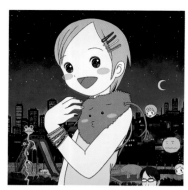

The artist known as "Mr." yearns for the otaku paradise of Akihabara.

Mr., *V*, 2005. Acrylic on canvas, 76½ x 76½ in.

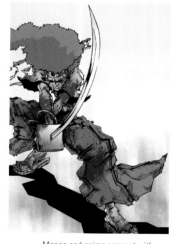

Manga and anime connect with some of the sensibilities that underlie Japanese art.

Takashi Okazaki, *Afro*, 2003. Indian ink and digital color on Kent paper.

anime frequently feature great explosions and catastrophes. Popular TV anime series *Dragonball Z* ran into trouble in France because of its violent content. Japan is also the home of Akihabara, a Tokyo district that has become a mecca for the otaku crowd, where over five hundred stores sell electrical goods and products relating to anime, manga, and computer games, with an annual gross of over ¥30 trillion between the years of 1996 and 2006,[4] and where "maid cafés" with waitresses dressed as manga characters draw a steady stream of international otaku tourists.

But beneath this veneer of cultural chaos and futuristic decadence lies another Japan: a Japan where centuries of spiritual tradition have been passed down through the generations. This is the Japan where Ise Shrine, the country's center of Shintoism, is pulled down and rebuilt every twenty years, a tradition that has continued for more than a thousand years, to ensure that this sacred place will stand for eternity. At the time of rebuilding, 800 types of sacred clothing, and 1600 other sacred items contained in the shrine are burned and replaced. The need to create these items every twenty years has meant that the necessary traditional skills have been passed down from generation to generation, nurturing and forming an important part of Japanese culture. Maybe this is the source of the obsessive attention to detail found in the manufacturing technologies of Japanese companies such as Sony, Toyota, and Honda, or in the Japanese-made computer games that flood the markets of the West.

In his classic essay on samurai ethics *Bushido* (which literally translates as "the Way of the Warrior"), first published in 1900 and still popular today, Inazo Nitobe attempts to explain the soul of Japan to Westerners. He argues that the traditions handed down through Buddhism, Shintoism, and Confucianism, and the moral guidelines by which Japan's samurai lived are the sources of the virtues of rectitude, courage, benevolence, politeness, sincerity, honor, loyalty, and self-control that are so valued by Japanese people. Nitobe argues that cherry blossom is an important symbol in the Japanese aesthetic. The fragrance of cherry blossom is faint but it does not bore people. It exists in nature without contention, and when the wind blows, it flies away gracefully. To live in accord with and not resisting the great force that is nature is the essence of Japanese life, according to the book. To despise cowardice, to carry out obligations with courage, and to be prepared to die to protect one's honor was the moral code by which the elite samurai warrior class lived. These values were passed on into popular consciousness through literature and theater, transforming and sublimating the rules of the battlefield into a mental and spiritual framework that still has resonance in today's Japan.

Japan's contemporary artists have an "operating system" that the Western art world may find difficult to decipher, because it is based on culture and traditions that are unfamiliar. But the recent worldwide boom in the popularity of Japanese manga and anime has opened a new door through which the rest of the world can connect with some of the sensibilities that underlie Japanese contemporary art. Manga artist Shiriagari Kotobuki says: "I think manga itself is very Japan. Especially where we choose to abbreviate, deform, signify, and make things with an unspoken mutual understanding with the reader. If you look at the basics of Western art as

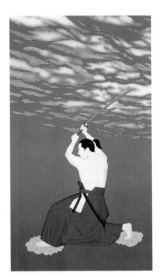

A new generation of artists echo the spirit of their samurai forbearers.
Hisashi Tenmyouya, *Bunshin,* 2005 (detail). Acrylic on wood.

an attempt to capture nature or reality, then in Japan you find that we try to just abbreviate things or not draw the thing itself but the shadow, hinting at the existence of something, or leaving things quite ambiguous. So we might just draw some beads of sweat to indicate the panic of a character walking past. Or actually have blank frames taking up space without much meaning . . . The strength of Japanese manga is that they handle emotions that people around the world can understand, in a way that is easy to handle . . . When you signify something or you try to communicate something, I believe there are little things that fall by the wayside—ambiguities that cannot be described in a word, that are neither black nor white. By trying too hard to signify these things, we lose something important. Those grey areas or chaotic things are part of the world . . ."[5] As Japanese contemporary artists go back and forth between nature and the city, Bushido and high technology, cuteness and violence, and yet other extremes, one senses the presence of unseen yet crucial issues.

As an art journalist, I feel proud to have witnessed at first hand the activities of many of the artists included in this book over a long period of time. I have been active in my support of up-and-coming artists, organizing a nonprofit organization to offer support and advice on legal matters, copyright, and funding, for example. Although awareness of Japanese contemporary art is growing overseas, many of the talented artists in this book are being introduced to the world outside Japan for the first time. Part of the reason they have been unknown abroad until now is because there are few venues in Japan where overseas curators can see the work of young Japanese artists on permanent display, or because the translated texts explaining their works are often insufficient. As I have pointed out in this introduction, another possible barrier is that the culture and traditions underpinning Japanese contemporary art are not well understood outside Japan. I suggest that to grasp the futuristic expressions coming out of Japan, one should think not in terms of concept but in terms of the sensation or feeling that the works inspire. I would also like to remind readers that the cool pop culture emanating from this distant Far Eastern archipelago sits side by side with the weight of two thousand years of cultural and spiritual tradition. I hope that this book will be the starting point for your own deeper exploration into the society that has given birth to these Warriors of Art, this new generation of artists who echo the spirit of their samurai forbearers as they boldly challenge us to share their vision of Japan.

Yumi Yamaguchi
Tokyo, 2007

1. Takashi Murakami, *Little Boy: The Arts of Japan's Exploding Subculture* (New Haven and London: Yale University Press, 2005), 4.
2. Ibid., 152.
3. Takashi Murakami, *Geijutsu kigyoron* (Tokyo: Gentosha, 2006), 233–4.
4. Ichiya Nakamura, *Nihon no poppu pawa* (Tokyo: Nihon Keizai Shimbunsha, 2006), 63.
5. *Nihonga Painting: Six Provocative Artists,* (Yokohama Museum of Art, 2006), 70–73.

Makoto Aida

Born 1965, Niigata Prefecture

With themes as diverse and unpredictable as sadomasochism, political satire, and absurd humor, and demonstrating extraordinary technical skill across a broad range of media, Makoto Aida stimulates his contemporaries, confuses curators, and imparts a powerful impact upon collectors. His 1993 work *The Giant Member Fuji versus King Gidora* combines the style of a traditional *ukiyo-e* woodblock print with references to the TV series *Ultraman* and to *Godzilla* movies. The underlying motif is derived from *Kinoe-no-komatsu*, a famous book of *shunga* (pornographic woodblock prints) by renowned *ukiyo-e* artist

Katsushika Hokusai (1760–1849), in which an octopus and a female pearl diver are locked in an erotic embrace. In Aida's gigantic ten-by-thirteen-foot piece, the three-headed monster King Gidora from *Godzilla* ravishes Akiko Fuji, a member of *Ultraman*'s Science Patrol, a special police force to protect Earth from invading monsters.

Aida seems to deliberately pick dangerous or scandalous themes. His work regularly deals with disturbing sexual images of pubescent girls—including a series depicting teenage amputees who are chained like dogs—and other taboo topics, such as criticism of the emperor system, but this does not seem to have diminished his popularity in Japan. His sensational subject matter, uniquely Japanese motifs, and underground flavor have also given this artist a global appeal.

THIS PAGE: *Giant Salamander*, 2003. Acrylic on wood panel, 126 x 168 in.

FACING PAGE, TOP: *Blender*, 2000–2001. Acrylic on canvas, 116 x 84 in.

FACING PAGE, BOTTOM: *Ai-chan BONSAI (Ground Cherry)*, 2005. Mixed media, 21 x 13 x 13 in.

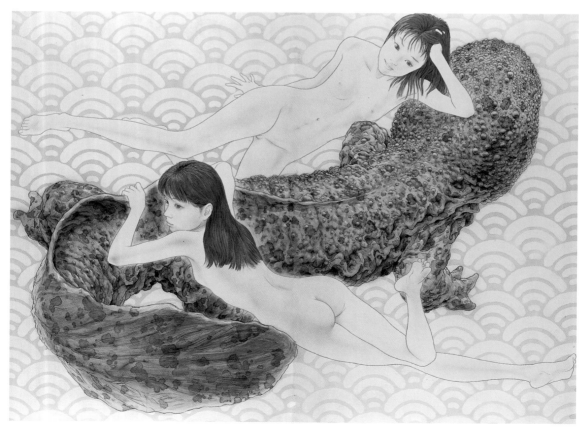

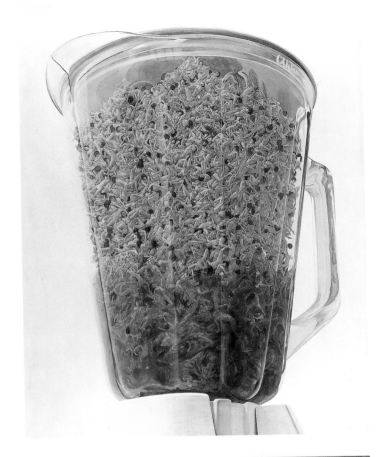

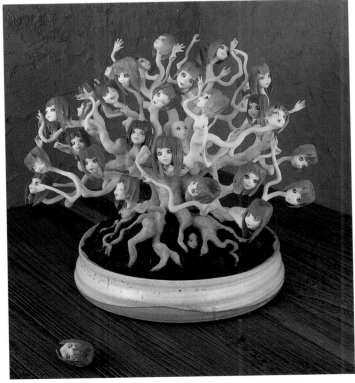

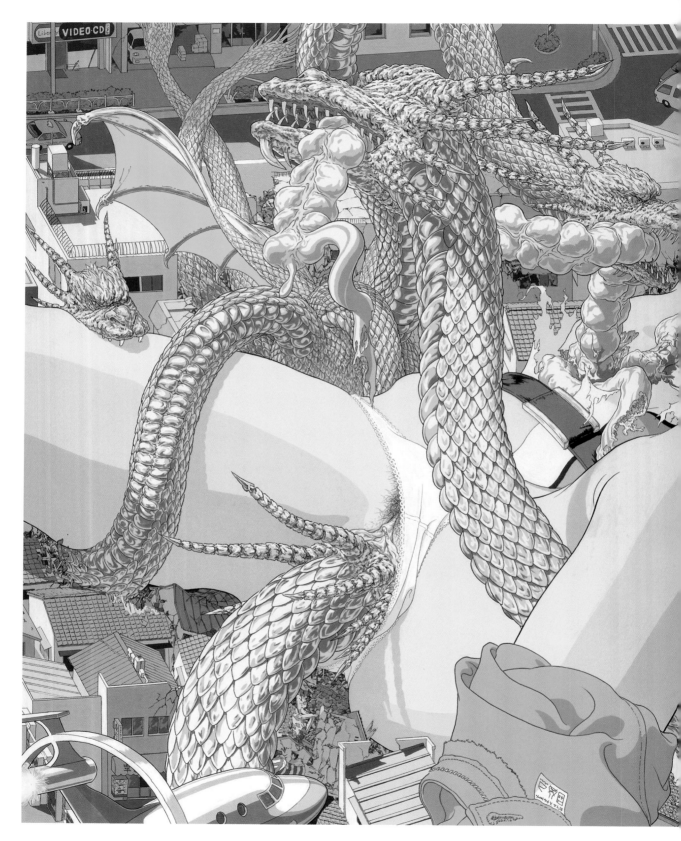

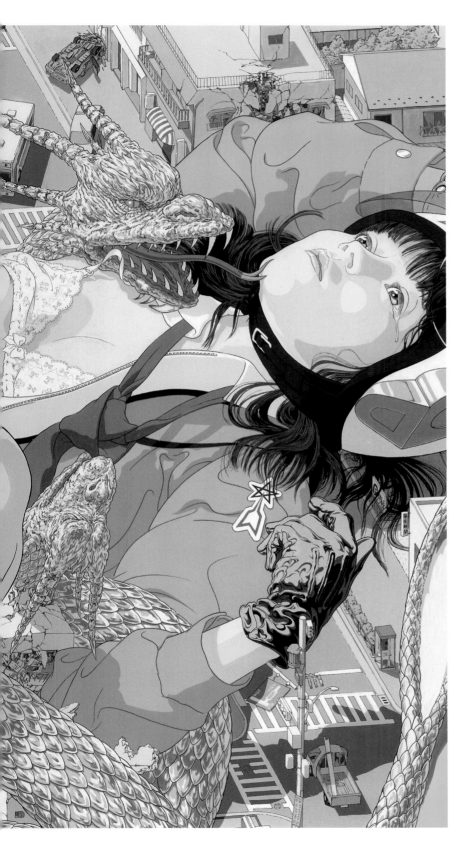

The Giant Member Fuji versus King Gidora, 1993. Acrylic and metal eyelet rings on acetate, 124 x 164 in.

Chinatsu Ban

Born 1973, Aichi Prefecture

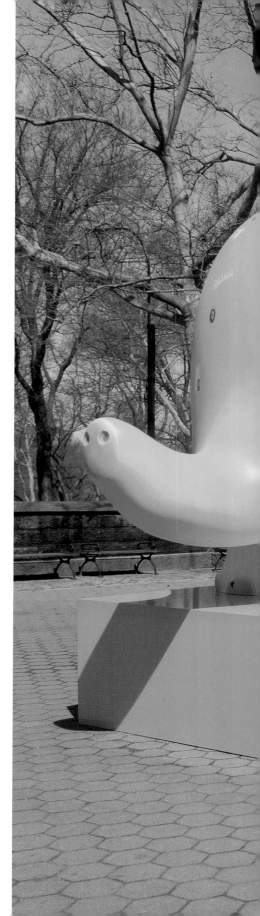

V W X Yellow Elephant Underwear/H I J Kiddy Elephant Underwear, 2005. FRP, steel, acrylic paint, urethane. Large elephant: 170 x 95¾ x 108¼ in. Small elephant: 48¾ x 28 x 28¾ in. Poop: 14½ x 14½ x 16 in.

The motifs in Chinatsu Ban's work would not be out of place in the baby goods section of a department store: elephants, poop, little girls, and brightly colored underpants. A member of Takashi Murakami's Kaikai Kiki stable, she participated in Murakami's Tokyo Girls Bravo 2 exhibition in 2002. In 2005 she had her first overseas solo show at the Marianne Boesky Gallery in New York, and took part in Murakami's Little Boy exhibition. Her bright yellow sculptures of a mother and baby elephant installed in Central Park as part of Little Boy attracted attention not only from the media, but also from children, who were particularly drawn to the multicolored piles of elephant dung that were part of the installation.

When asked why elephants feature so strongly in her work, Ban replied: "Elephants are like a lucky charm for me. The thought that one day I will cease to exist in this world fills me with dread. Elephants make me feel calm and help me block out these fears. They've saved me many times." She affectionately calls her elephant characters "Pan-chan," a pun on both the underpants they wear, and her own name.

Ban's works are not merely cute: elephants' trunks and underpants carry obvious sexual overtones. But this childlike, direct expression of desire is an unaffectedly honest portrayal of human sexuality and the desires that lurk in all of us.

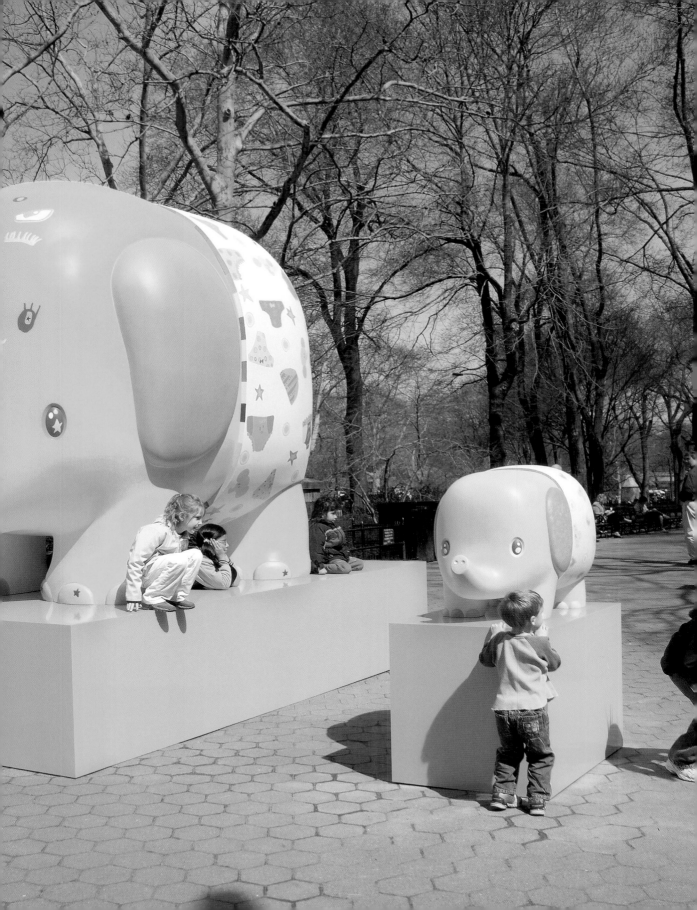

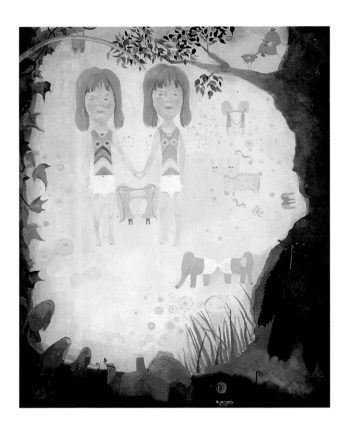

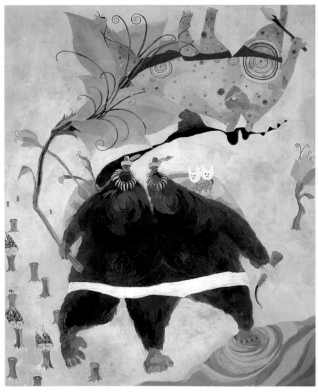

THIS PAGE, TOP LEFT: *The Song of Twin DNA*, 2005. Acrylic on canvas, 64 x 51 in.

THIS PAGE, TOP RIGHT: *A Twin Story (Hunter)*, 2006. Acrylic on canvas, 64 x 51 x 1 in.

THIS PAGE, BOTTOM: *A Twin Story (The Sum of it All)*, 2006. Acrylic on canvas, 64 x 51 x 1 in.

FACING PAGE: *A Twin Story (Paradise)*, 2006. Acrylic on canvas, 44 x 57 x 1 in.

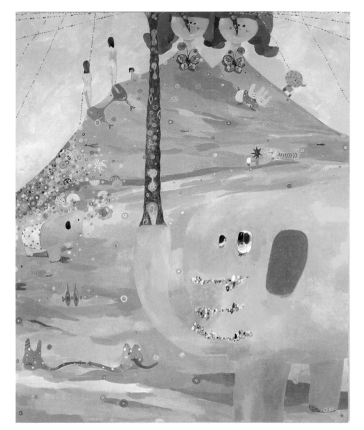

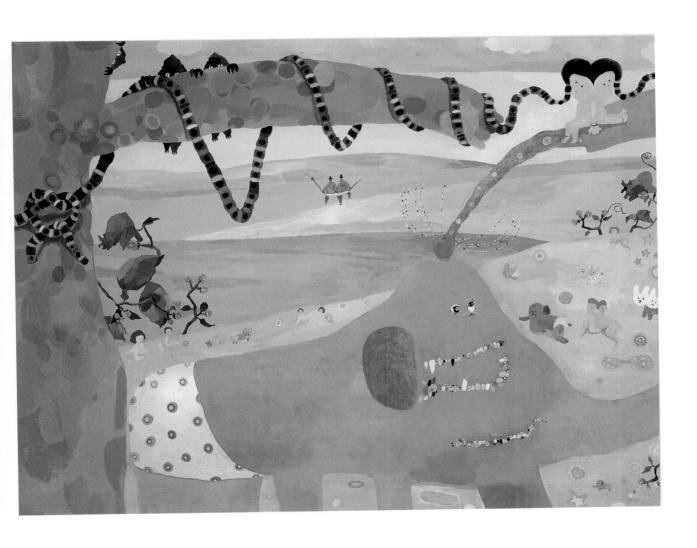

Hideomi Fukuchi

Born 1973, Saga Prefecture

Hideomi Fukuchi's paintings of manga-style fighting girls caused a stir at the Artificial Paradise group exhibition at Tokyo's Bunkamura Gallery in 2005. In Japanese anime and manga, the *sento bishojo* (which literally translates as "fighting beauty") is a staple genre: the beautiful teenage girl cast in the central heroic role of fighting against evil, weapon in hand.

It is not unusual for *sento bishojo* to have supernatural powers, but Fukuchi distorts and exaggerates the fighting beauty stereotype. Three-legged girls fly through the air, and a ripped-off limb lies casually discarded, the fighters seemingly oblivious to pain and injury. In the *Peachies* series, the girls have the pneumatic breasts and impossibly long legs of the typical anime heroine, but they also have rippling stomach muscles, oversized hands and feet, and they glare down at the viewer with ferocious expressions, brandishing clubs and cleavers.

Fukuchi works on transparent OHP projection sheets using acrylic paint, and at first glance his work resembles cel drawings of the type used in animation films. But this is no simple attempt to directly transfer anime subculture into the realm of high art. Like Takashi Murakami, whose *Time Bokan* series is influenced by the eponymous 1970s television anime series, Fukuchi's work explores the possibility of an expression of artistic integrity using the anime genre.

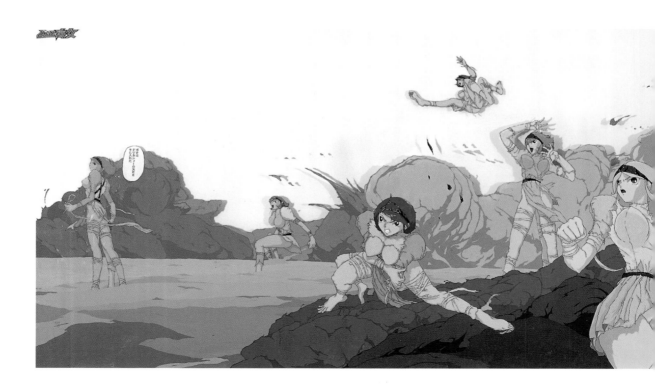

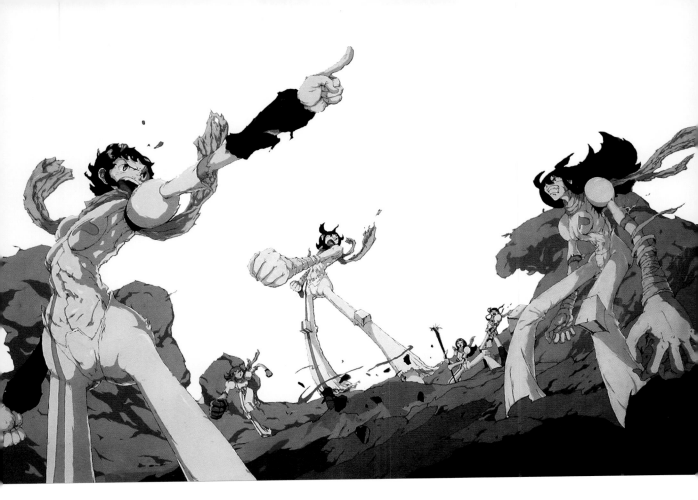

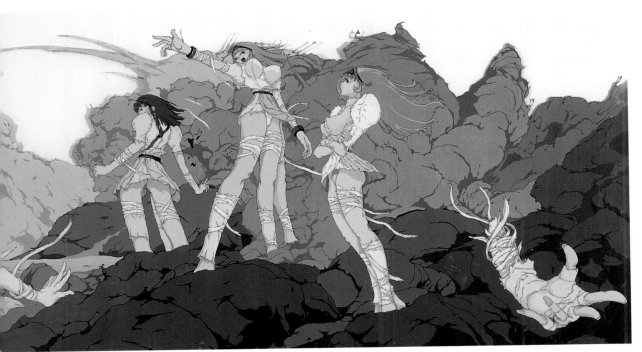

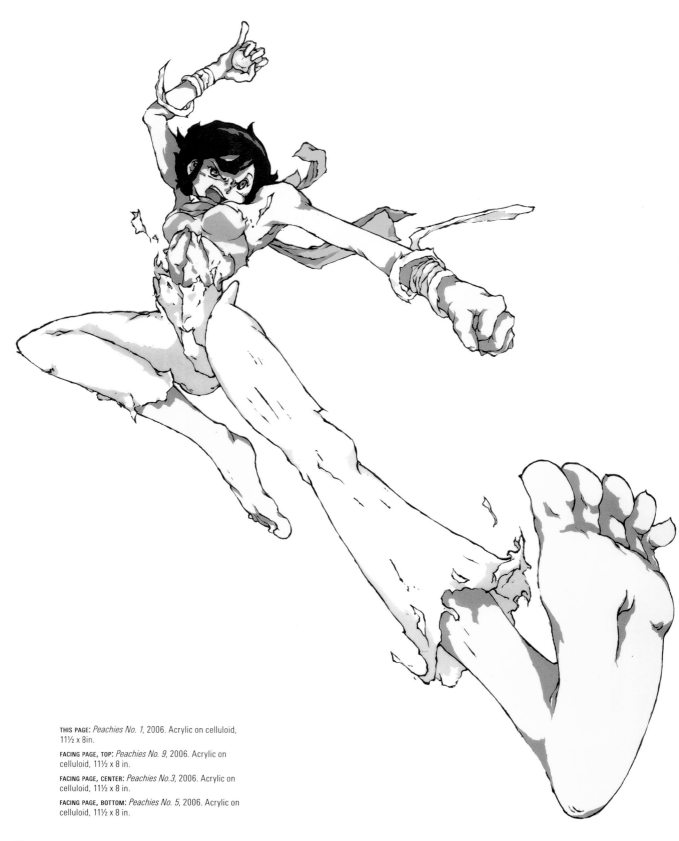

THIS PAGE: *Peachies No. 1*, 2006. Acrylic on celluloid, 11½ x 8in.

FACING PAGE, TOP: *Peachies No. 9*, 2006. Acrylic on celluloid, 11½ x 8 in.

FACING PAGE, CENTER: *Peachies No.3*, 2006. Acrylic on celluloid, 11½ x 8 in.

FACING PAGE, BOTTOM: *Peachies No. 5*, 2006. Acrylic on celluloid, 11½ x 8 in.

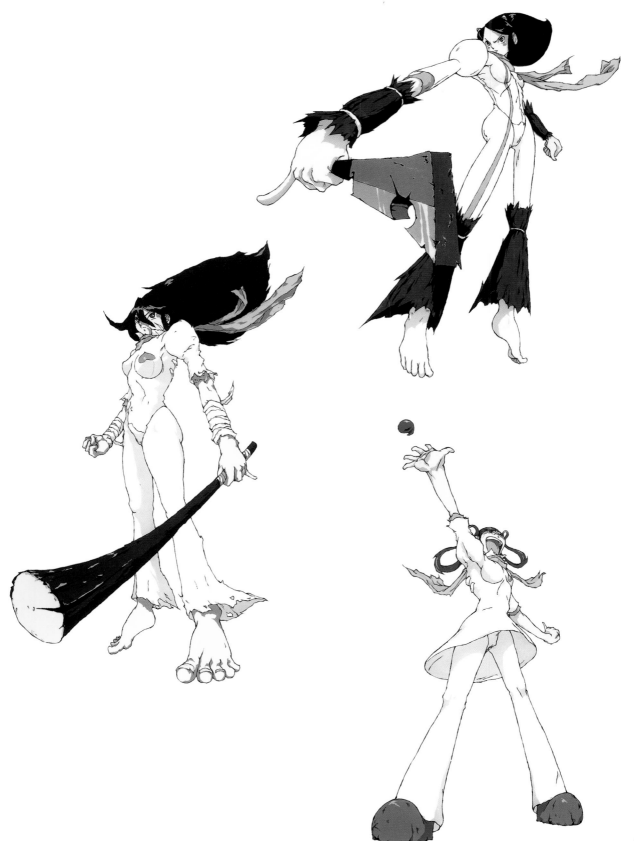

Ken Hamaguchi

Born 1975, Nagasaki Prefecture

There is a long tradition of captioning in the history of painting both in Asia and the West—a format that encourages the audience to think about the meaning and themes of the work. In Japan, this technique is often seen on the scroll paintings that adorn the walls of rooms where the tea ceremony takes place.

The title of Ken Hamaguchi's series of paintings *Maka hannya haramita shingyo* is the Japanese translation of the title of the Buddhist sutra *Prajna paramita hridaya*, which is known as the *Heart Sutra* in English. The *Heart Sutra* features a piece of wisdom taught in Buddhism that says: "A heart that does not obsess can reach the state of enlightenment." The paintings in this series show a woman with an enticing smile behind each of the Japanese *kanji* characters that make up the title of the sutra. Both temptation and enlightenment are crammed into the frame as art takes up a quintessential position between two polar extremes.

The title of the series *Rengo kantai* means Combined Fleet; a caption that summons up an image of male military might that is far removed from the pictures of women in erotic poses. This gap between caption and picture gives us the sense of witnessing something illicit, illuminated dimly behind a black-framed window.

In both these works, the bold composition harks back to frames in manga comic books, yet Hamaguchi has the technique to bring life to the solidness of the woman behind the flat black calligraphy. The beautiful skin tones and soft light in *Rengo kantai* give the work the resplendent beauty of a religious painting.

In *Movement 1998*, the juxtaposition is not of caption and picture but of images of sex, violence, *yakuza*, and cute schoolgirls against a swirling pop background, a scenario that calls to mind the seedy underbelly of downtown Tokyo districts such as Shibuya or Ikebukuro.

THIS PAGE: *Rengo kantai*, 2002. Acrylic on canvas, each frame 23½ x 23½ in.

FACING PAGE: *Maka hannya haramita shingyo*, 2006. Acrylic on canvas, each frame 7 x 7 in.

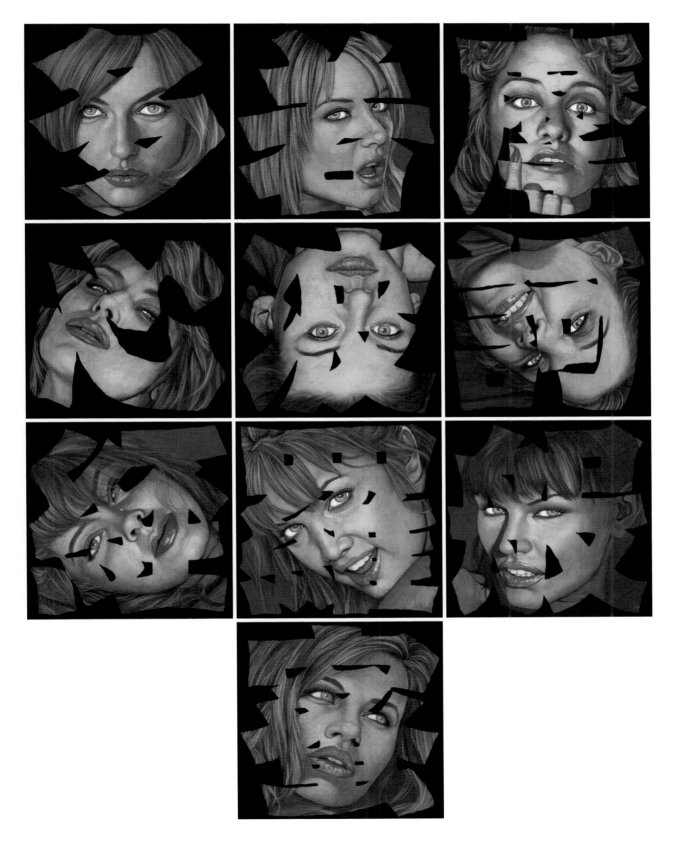

Movement 1998, 1998. Acrylic on illustration board, 9½ x 20 in.

Takanori Ishizuka

Born 1970, Kanagawa Prefecture

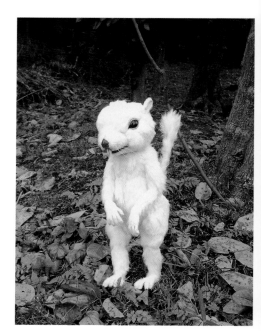

Originally a graphic designer, the catalyst for Takanori Ishizuka to start painting seriously came in 1996 with the deaths of two major forces in the Japanese creative world: influential modern artist Taro Okamoto, and Fujio F. Fujiko, creator of popular Japanese cartoon cat Doraemon.

"The first time I went to a Taro Okamoto exhibition, I was completely awestruck at the life force flooding out of his work, and that was the moment when I decided I had to become an artist," recalls Ishizuka.

Inspired perhaps by Okamoto's vitality, and by the bright, healthy optimism that is a characteristic of Fujiko's work, the small creatures that inhabit Ishizuka's world appear to be living life to the full—eating, playing,

sleeping, copulating, and perpetuating the cycle of life—despite their frailty and short life spans. But the artist manages to convey more than a simple sense of vitality; he provokes in the viewer a feeling that there is something rather repugnant about the lives depicted. The beauty of the embrace of the two small animals in *White Lovers*, for example, contrasts with their sharp claws and bodies which, upon closer inspection, are rather grotesque and fleshy. In *The Birth of Venus*, the image of the red fruit pierced by Cupid's arrow caught in the mouth of the animal with the rainbow-colored coat appears to reflect some kind of decisive moment, yet the blank expression on the animal's face is at odds with the tension created. Ishizuka's deceptively cute creatures leave us with a sense that beneath the surface we are all unthinkingly embroiled in a struggle for the survival of the fittest in a harsh world.

THIS PAGE, TOP: *Field 2* from the series *Landscape of White Lovers*, 2003. Mixed media, 17 x 6 x 14½ in.

THIS PAGE, BOTTOM: *Sanbiki dansu* from the series *Landscape of White Lovers*, 2003. Mixed media, each figure 17 x 6 x 14½ in.

FACING PAGE: *White Lovers*, 2003. Acrylic and oil on canvas, 13 x 12 in.

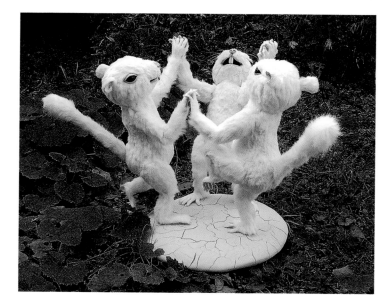

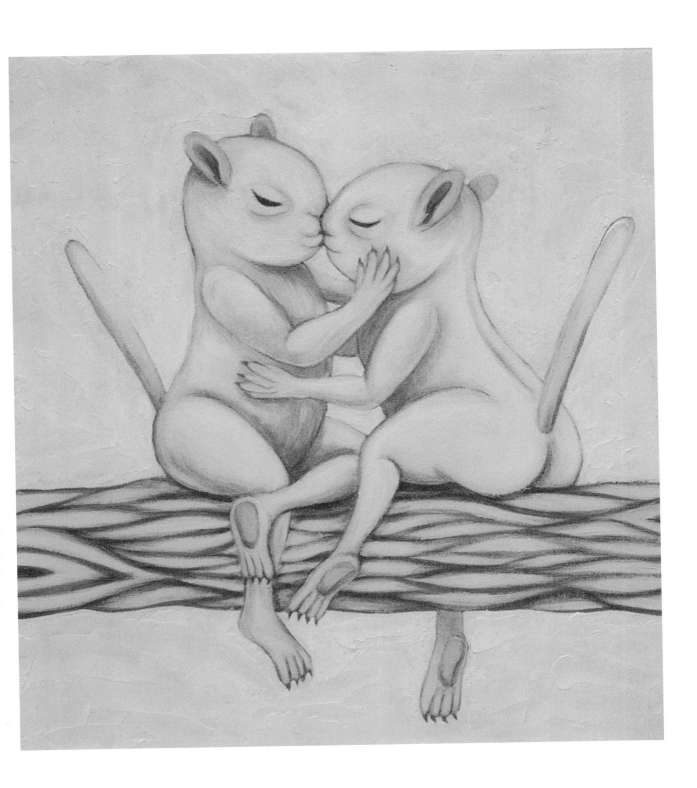

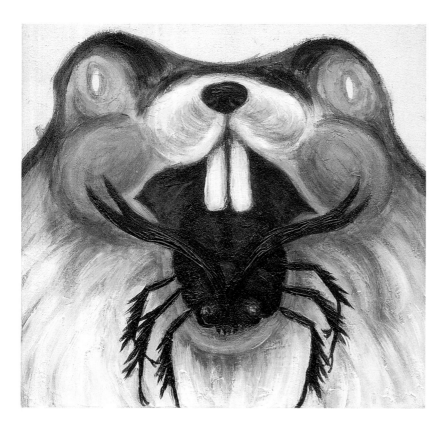

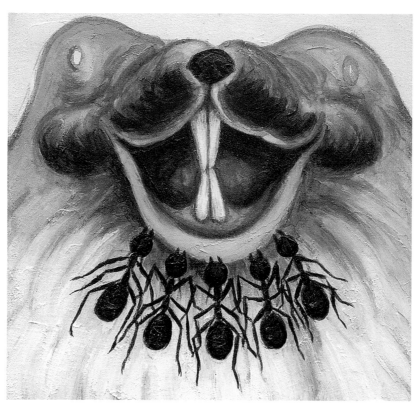

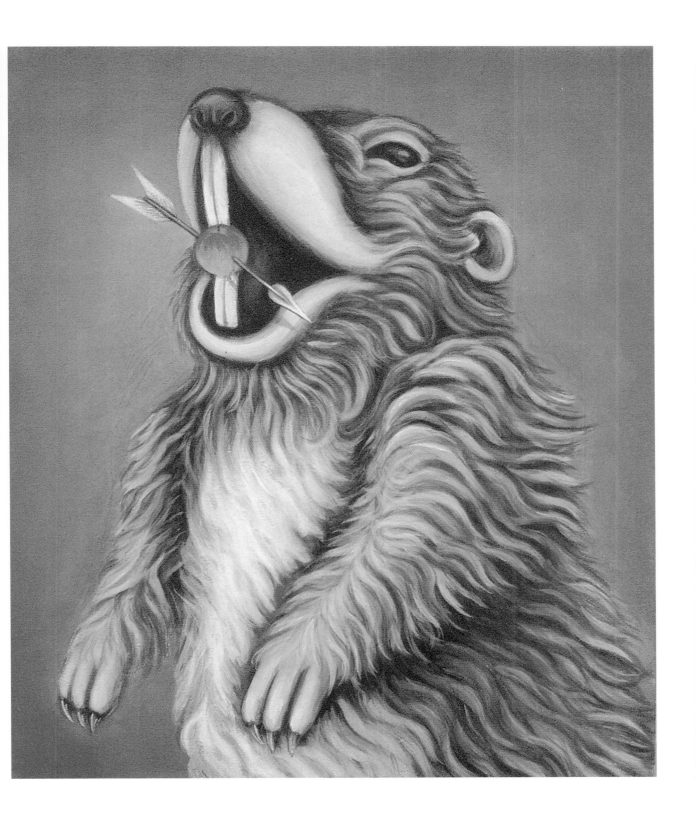

Izumi Kato

Born 1969, Shimane Prefecture

THIS PAGE: *Untitled*, 2004. Oil on canvas, each panel 39 x 28½ in.

FACING PAGE: *Hadaka no hito*. Wood, acrylic, charcoal, silicon. Figure on left, 22½ x 17 x 9 in. Right hand side top figure, 34 x 10 x 12½ in. Right hand side center figure, 19½ x 47 x 12 in. Right hand side bottom figure, 12 x 35½ x 12½ in. Installation view, Scai the Bathhouse, Tokyo, 2005.

Transparent gel covering three embryonic bodies. A figure that could be man or beast . . . the work of Izumi Kato initially appears abstract and grotesque. But in fact the artist is giving us an extremely concrete portrait of an unease he recognizes in us all. His sculptures are awkward and unsteady, with large heads and uncertain proportions. His characters seem childlike in their helplessness, but the emphasis the artist gives to their genitalia makes us feel that these figures are adults.

Kato does not work with a brush, but applies paint by hand, wearing a vinyl glove. To choose such a difficult way of painting seems to be a statement against a Japan where everything is easy to procure, and can be interpreted as a gesture of the artist's frustration with contemporary society. Psychiatrist and art critic Tamaki Saito has pointed out the resemblance of Kato's work to that of the Anglo-Irish painter Francis Bacon (1909–1992), whose distorted human forms also seem to suffer from a psychic pain they cannot articulate.

The sense of anxiety and confusion conveyed by these figures that look like infants but also like elderly people produces an intuitive recognition of ourselves in his work, and a love grows. Kato reminds us of our primal attraction toward those who need our care, and of our often forgotten fundamental love for our fellow human beings.

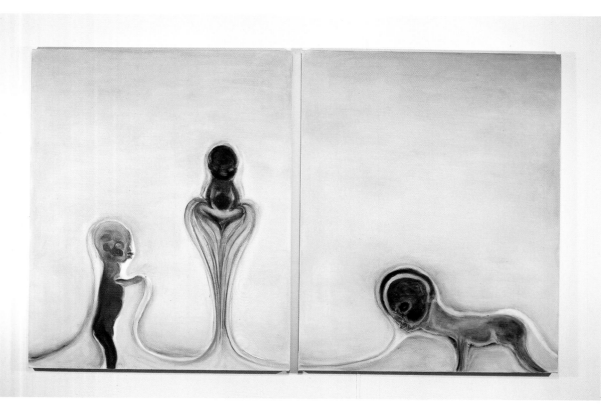

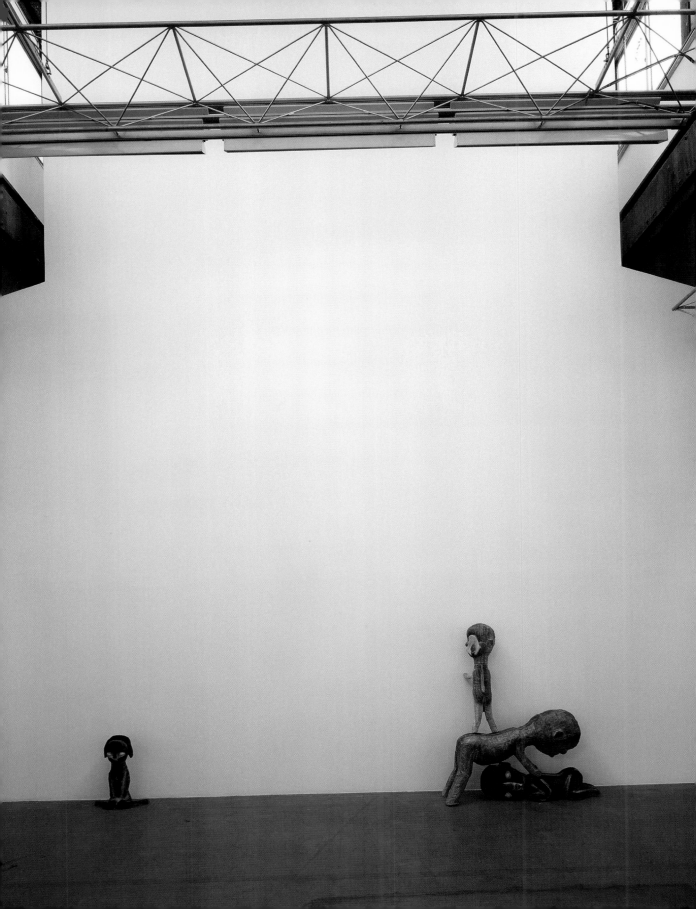

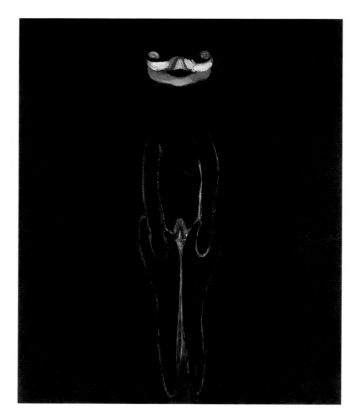

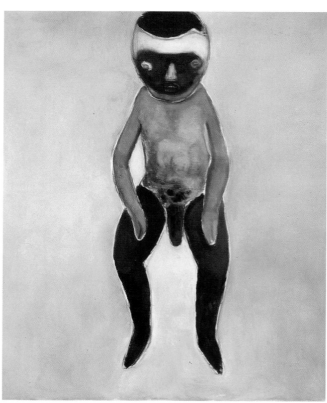

THIS PAGE, TOP: *Reticence*, 2000–2001. Oil on canvas, 64 x 51 in.
THIS PAGE, BOTTOM: *Reticence*, 2000. Oil on canvas, 64 x 51 in.
FACING PAGE: *Untitled*, 2006. Oil on canvas, 76 x 51 in.

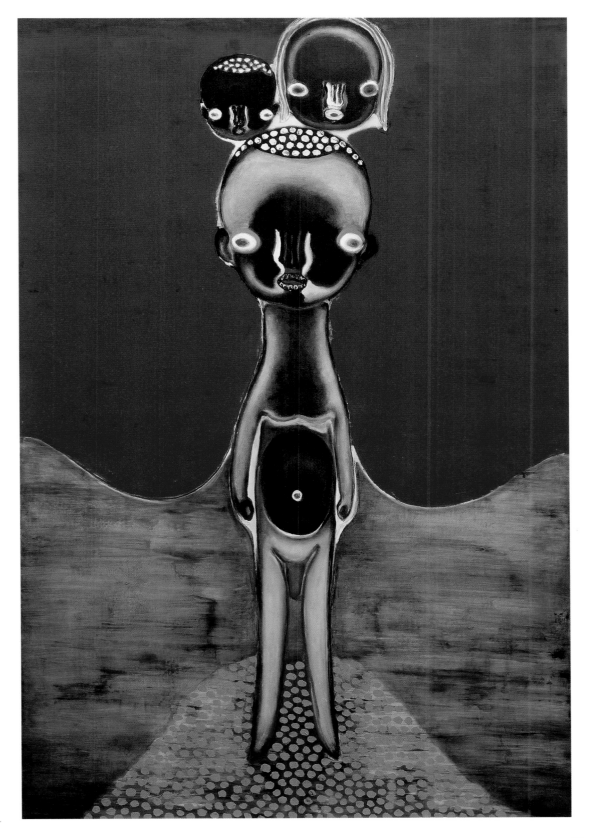

Mika Kato

Born 1975, Mie Prefecture

Mika Kato made her debut with a solo exhibition at Tokyo's Tomio Koyama Gallery in 2000, when she was still a postgraduate student in the Department of Oil Painting at Aichi Prefectural University of Fine Arts and Music. Her large-scale paintings feature girls with very distinctive large eyes, wearing eccentric clothes and accessories. The girls' faces have odd expressions and slightly deformed proportions, which makes them look like dolls. It all makes sense when you learn that in order to paint Kato first sculpts a doll from clay, chooses clothes for it, and then photographs it over a period of time until she has built up a sense of the doll's character. Only then does she start to paint, using the doll as a model.

This laborious process, coupled with Kato's outstanding technical skill as an oil painter, results in portraits that are strikingly realistic but at the same time otherworldly. The girls she depicts have an appealing beauty, but there is also something frightening about them. In *Gossamer*, scabs peek out from the under the unruly eyebrows of the little girl. In *Peaberry*, the girl nestles up to a decaying animal skull. These grotesque elements do nothing to deter Kato's fans, who have even approached the artist with requests to buy the dolls and photographs she works from. Kato, however, refuses these requests, seeing the dolls and photographs not as works of art in themselves, but as part of a long creative journey during which her work develops from doll to photograph to painting, maturing in the process, like fine wine.

THIS PAGE: *Soda*, 2000. Oil on canvas, 77 x 77 in.
FACING PAGE, TOP: *Constellation*, 2004. Oil on canvas, 95 x 88 in.
FACING PAGE, BOTTOM: *Canaria*, 1999. Oil on canvas, 76 x 76 in.

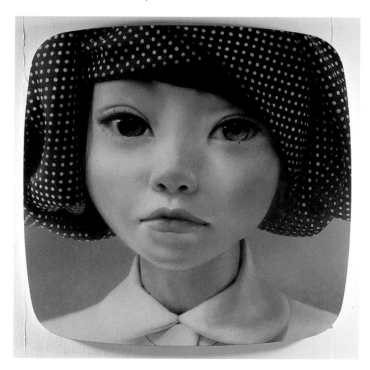

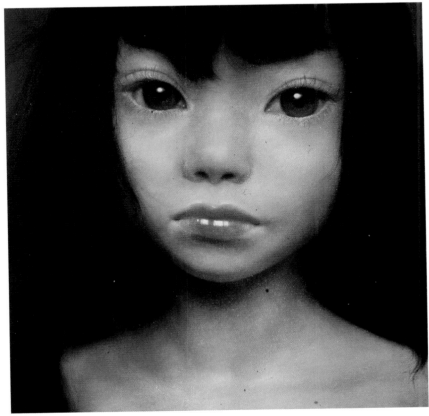

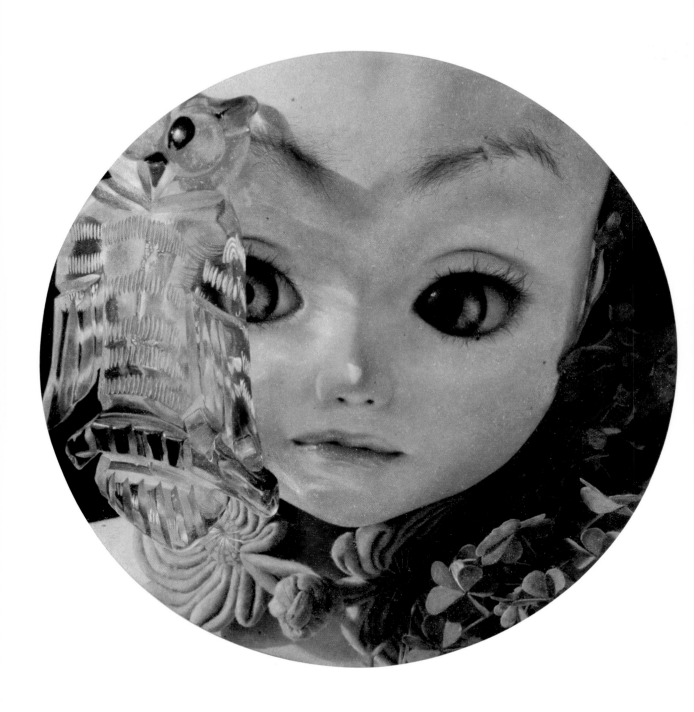

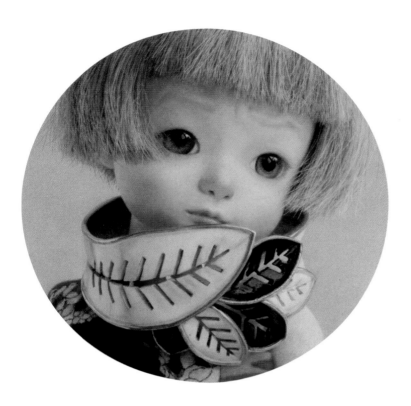

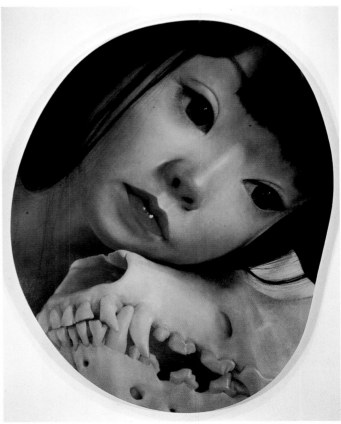

FACING PAGE: *Gossamer*, 2005. Oil on canvas, diameter 48 in.

THIS PAGE, TOP: *Kanten*, 2005. Oil on canvas, diameter 48 in.

THIS PAGE, BOTTOM: *Peaberry*, 2001. Oil on canvas, 92½ x 73½ in.

Hideaki Kawashima

Born 1969, Aichi Prefecture

After graduating from Tokyo Zokei University, Hideaki Kawashima made an unusual career move, spending two years in meditation training at Kyoto's Enryaku-ji Temple, the center of the Tendai Buddhist sect. Although he did not become a monk, his meditation training has given him great focus in his artistic expression.

Since his appearance in the exhibition Morning Glory, curated by Yoshitomo Nara at the Tomio Koyama Gallery in Tokyo in 2001, Kawashima has taken part in a variety of solo and group shows both in Japan and overseas, including Takashi Murakami's Little Boy exhibition in New York in 2005.

Kawashima's portraits depict faces of indeterminate gender with pale skin and often with long white hair like ghosts. In sharp contrast to the soft colors of the skin and hair are the eyes, which are painted with strong blues and greens, and patterned with fine lines that seem to reflect light in a myriad of directions. Kawashima says he paints the faces "as if they were self-portraits," and that his motivation comes from a desire to confirm his existence. "It's the kind of feeling everybody has experienced. Like looking at one's own reflection in a train window late at night, and thinking how flimsy and uncertain this thing called the 'self' is."

Kawashima's work gives a sense of the fleetingness of life, as well as the narcissism of human beings. He takes the anxiety we all share as we wonder who we really are, and transforms our fears into beautiful paintings.

THIS PAGE, LEFT: *Up*, 2005. Acrylic on canvas, 18 x 15 in.

THIS PAGE, RIGHT: *Soak*, 2004. Acrylic on canvas, 64 x 51 in.

FACING PAGE: *Light*, 2006. Acrylic on canvas, 89 x 71½ in.

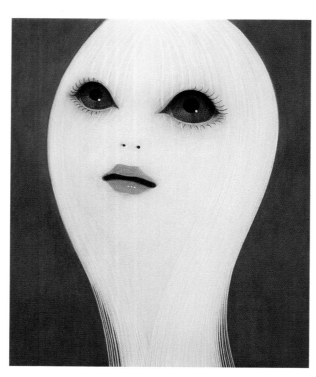
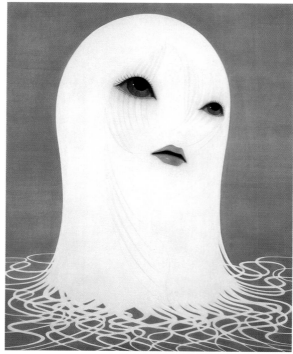

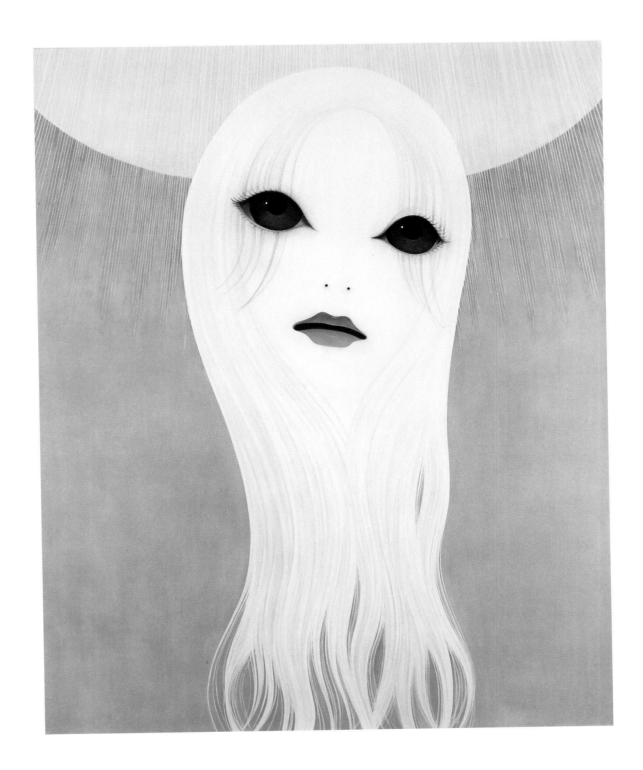

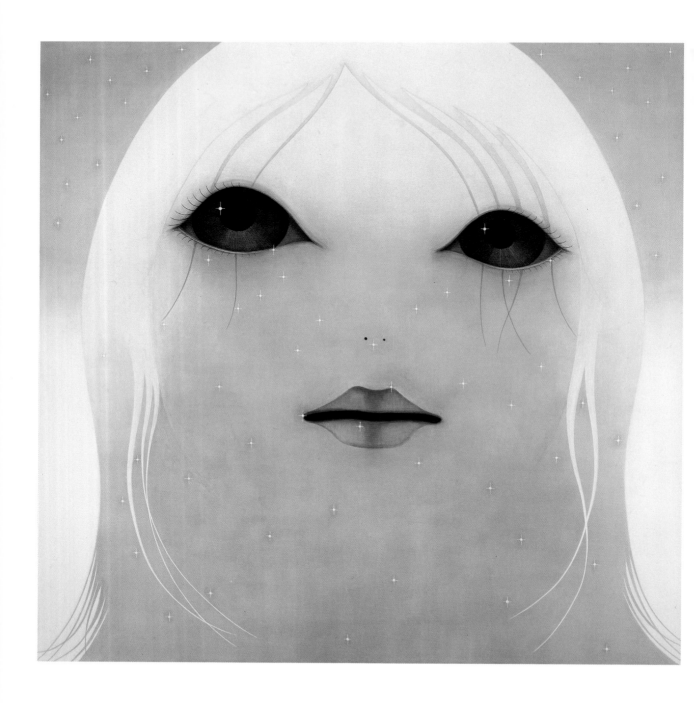

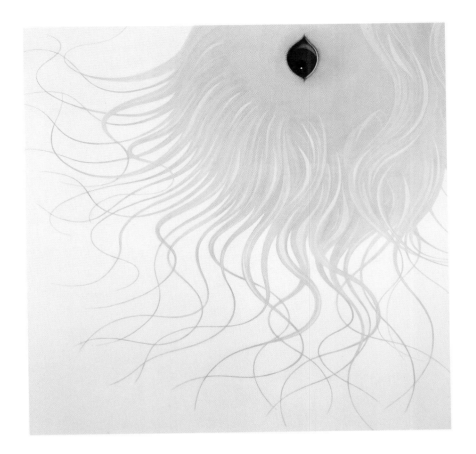

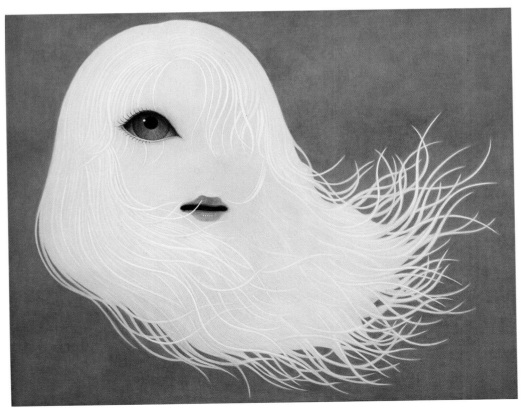

Maiko Kobayashi

Born 1977, Kanagawa Prefecture

Maiko Kobayashi first came to the public's attention at a group exhibition held in 2002 at the Omotesando Gallery in Tokyo. By 2004 her popularity had grown to such an extent that she was the star of a solo show at the same venue. Visitors to her exhibitions have no doubt wondered about the exact nature of the strange creatures that feature in her work. They are animal-like, yet they are neither dogs, cats, rabbits, nor sheep. "I can't paint humans," says Kobayashi. "But these are not comic-book type characters either."

Looking at her work, we sense that rather than starting out with the goal of painting a specific preconceived image, Kobayashi allows her hand to move across the canvas in time to the rhythm of her own transient moods and feelings. The work *Untitled 2004* (*Sequence of Inspiration*) for example, although large, at more than ten feet wide, was obviously allowed to build up gradually without any prior plan, with pieces of paper added as the picture grew. The eyes and mouths of the creatures who stare out at the viewer are too simple to convey much emotion, but the long limbs and rounded ears give off a gentle air, while a kind of tension is created from the contrast of rough black outlines against thin white paper.

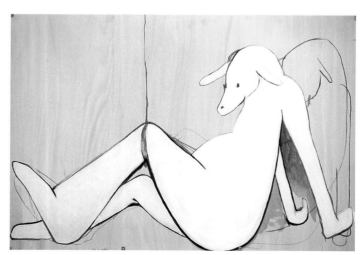

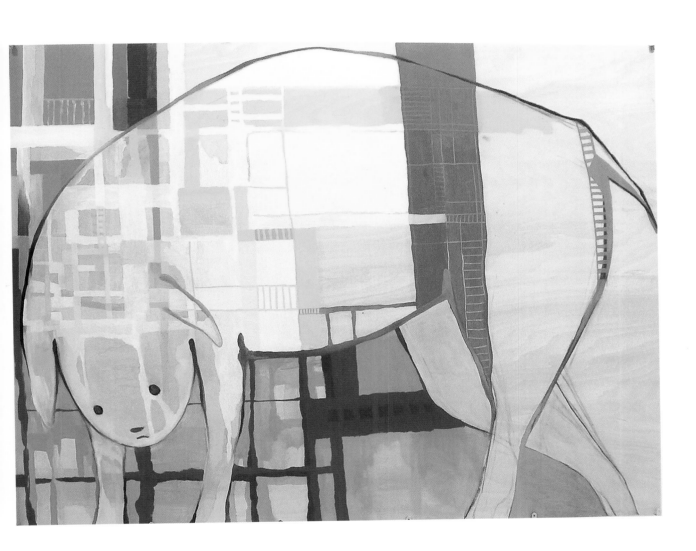

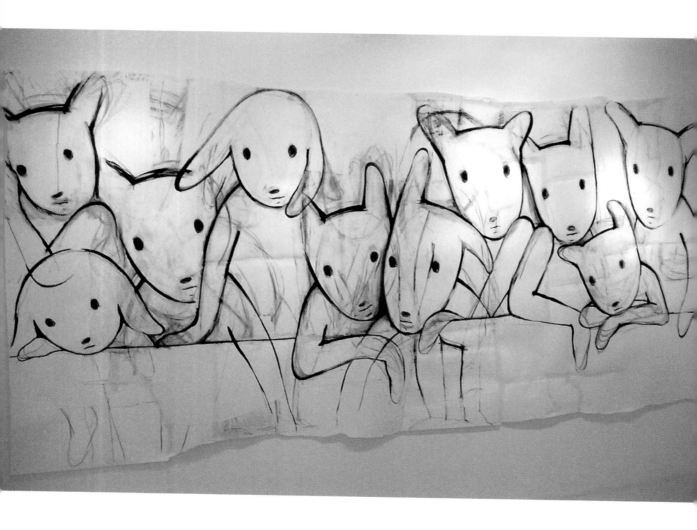

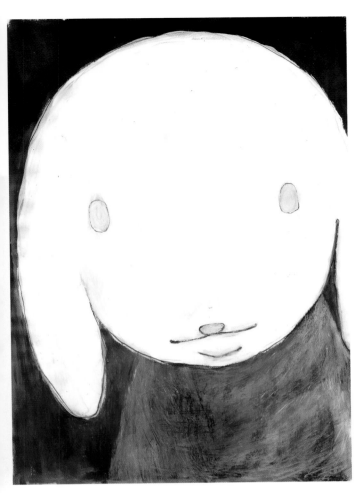

FACING PAGE: *Untitled 2004 (Sequence of Inspiration)*, 2004. Pencil, charcoal, oil crayon, acrylic, gesso, and paper tape on paper, 55 x 126 in.

THIS PAGE, TOP: *A Night Song*, 2002. Oil crayon, ballpen, pencil, and gesso on paper, 14 x 10 in.

THIS PAGE, BOTTOM LEFT: *Untitled*, 2003. Water-soluble pen on paper, 6 x 4 in.

THIS PAGE, BOTTOM RIGHT: *Untitled (drawing for "Daily Songs")*, 2003. Water-soluble pen, watercolor pencil, and pencil on paper, 14½ x 10 in.

Naoki Koide

Born 1968, Aichi Prefecture

Naoki Koide graduated from the Department of Fine Art at Tokyo Zokei University in 1992, and came to prominence in 2003 when he took part in the group exhibition Magic Room at Tomio Koyama Gallery's Project Room, curated by noted collector and psychiatrist Satoshi Okada. In 2004 his solo exhibition A Couple in the Bathroom and his sculptural contribution to the Tomio Koyama Gallery booth at the Swiss art fair Art Basel both attracted a great deal of attention.

Koide describes himself as part of "the manga generation." His works are mostly sculptures made from fiberglass-reinforced plastic, and photographs of these sculptures taken in various locations. The figures he sculpts have peculiarly long heads and limbs and very smooth, shiny surfaces, so they look like humorous cartoon characters. Inspiration for the characters often comes from family and friends. In his series *Marriage*, which features a couple at a wedding, the figures represent Koide and his wife with their family at their own wedding.

The figures in Koide's work sit or stand simply side by side, but as we see them depicted in various scenes we begin to sense the subtle relationships between the characters, and start to worry for them, or feel amused. Koide's work has a strange quality that allows us to empathize with cartoonlike sculptures in a way that we cannot empathize with more realistic works. Perhaps it is precisely because of their cartoonlike nature that we are able to do so.

BELOW: *Marriage (parents)*, 2006. C-print, 39½ x 49 in.

FACING PAGE, TOP AND BOTTOM: Marriage. Installation view, Tomio Koyama Gallery, Tokyo, 2006.

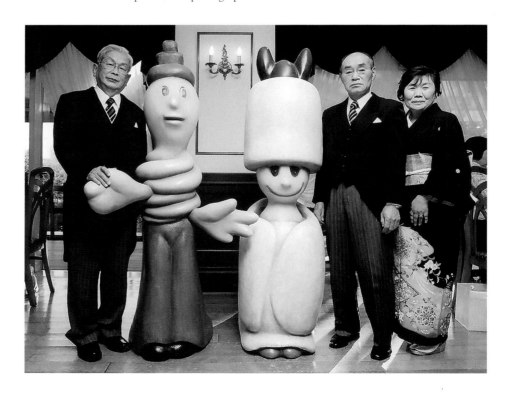

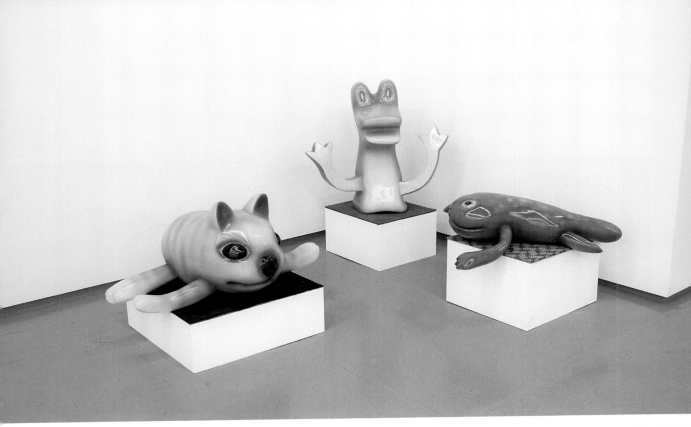

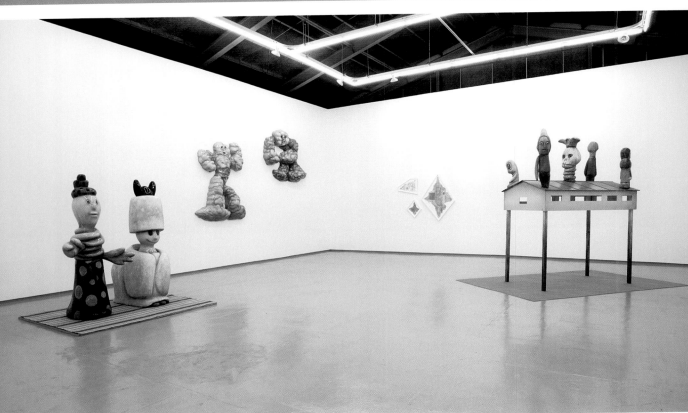

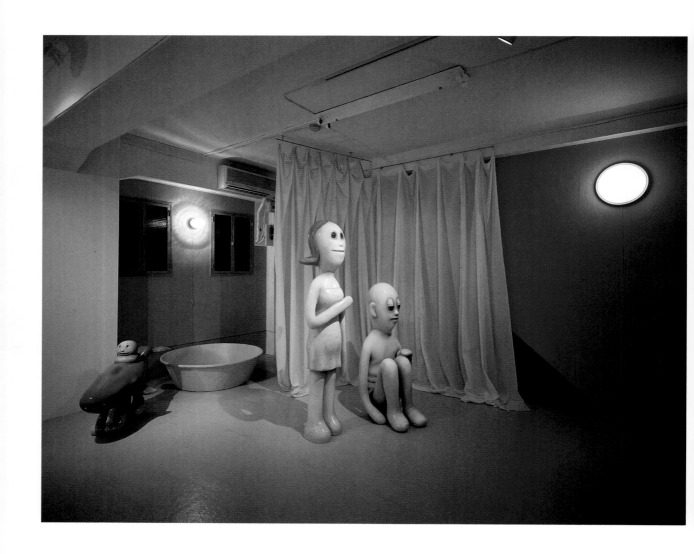

ABOVE: A Couple in the Bathroom. Installation, Tomio Koyama Gallery, Tokyo, 2004.

FACING PAGE: *Undead Family*, 2003. FRP, acrylic, urethane, lacquer. Undead Papa 51 x 25 x 19½ in., Undead Mama 67 x 21½ x 18 in., Undead Brother 59 x 17½ x 31½ in., Undead Boku 49½ x 23 x 14 in., Undead Dog 25 x 34½ x 13½ in. Installation, Art Tower Mito, 2004.

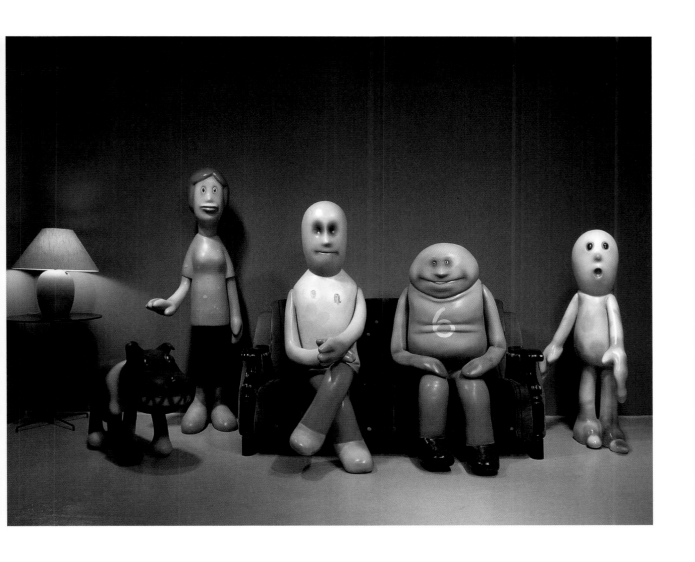

Sako Kojima

Born 1976, Tokyo

Sako Kojima works using a wide variety of media, but one thing that her pieces have in common is a sensational element. Works such as a sculpture of a sheep licking its own anus, or a performance where the artist lives in an art gallery as a hamster for a week, have shocked and intrigued audiences around the world.

Seen from afar, the animals that feature in Kojima's work appear cute, but as we rush towards them, we gradually start to recoil in horror at the gory details. This juxtaposition of cute and scary is referred to as *kimo-kawaii* in Japanese, a sensibility that seems to appeal to a younger generation of art lovers in Japan, who flock to Kojima's exhibitions.

Kojima's sculptures have soft or rugged textures that make us want to touch them. Of course, it is a basic understanding that we cannot touch works of art, but by creating this desire in the viewer, Kojima is able to draw us further into her world. In works such as *On the Big Chair* the delicate softness of a newborn baby's skin is combined with an adult masochism, a reflection perhaps of a Japanese society where there is no clear dividing line between the culture of children and that of adults. The work also conveys something of the irony and sadness of human existence, one of Kojima's major preoccupations.

THIS PAGE: *I Can Be Alone Twin*, 2004. Pencil and acrylic watercolor on paper, 11 x 13½ in.

FACING PAGE, TOP: *Inside Forest in Her.* Installation view, Fondation Cartier, Paris, 2005. Polystyrene, resin, artificial flowers, 27 in. (tallest) to 6 in. (smallest).

FACING PAGE, BOTTOM: *Girl*, 2005. Pencil and acrylic watercolor on paper, 14½ x 17½ in.

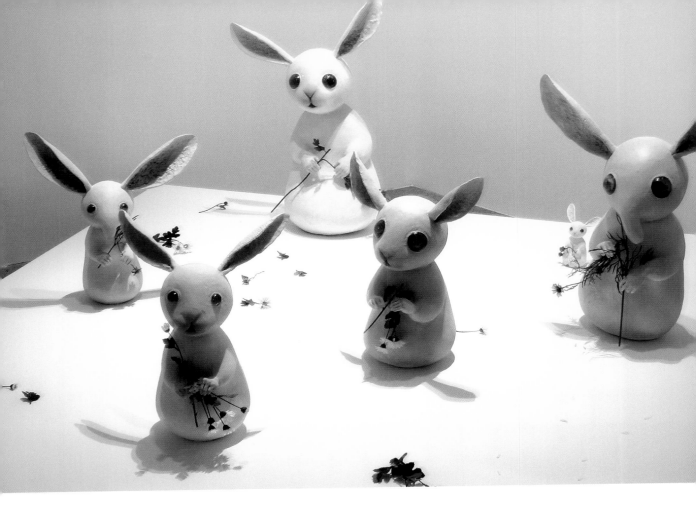

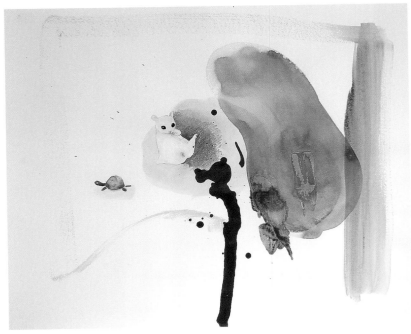

THIS PAGE, ABOVE AND RIGHT: *The Reason Why I Become Hamster*. Performance, Collection Lambert, Avignon, 2004.

THIS PAGE, BOTTOM: *I Can Be Alone 2*, 2005. Polystyrene, resin, mixed media, 36½ x 36½ x 21 in.

FACING PAGE: *On the Big Chair*, 2005. Fur, resin, acrylic, mixed media, 12 x 7½ x 8 in.

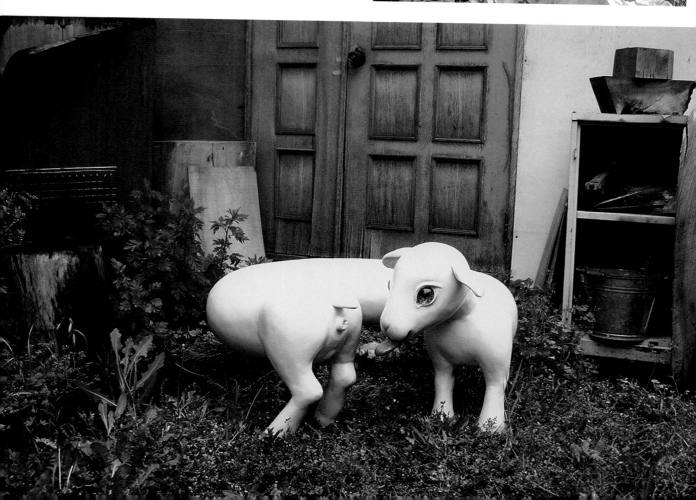

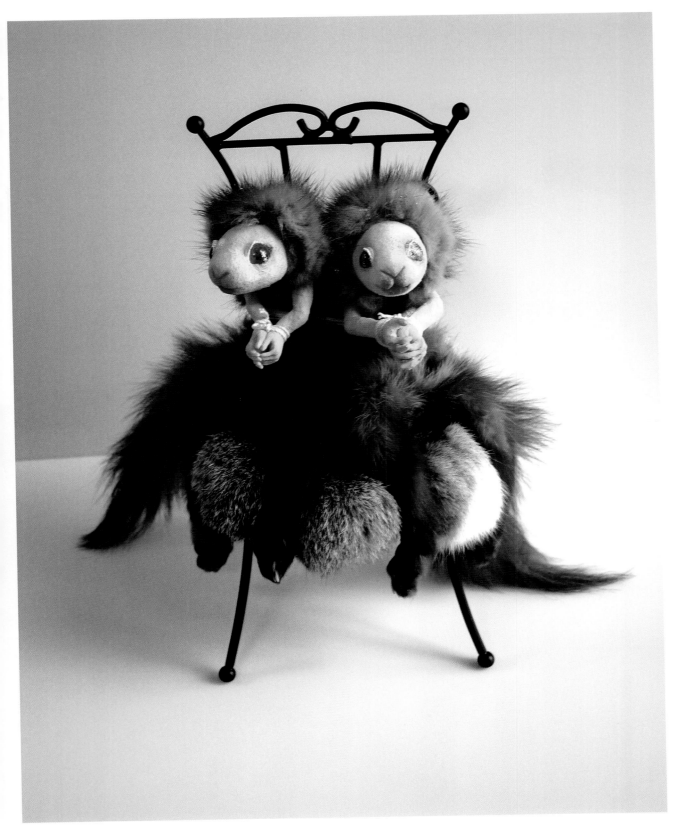

Tomoko Konoike

Born 1960, Akita Prefecture

THIS PAGE: *Chapter One*, 2006. Acrylic and sumi on kumohadamashi paper mounted on wood panels. 86½ x 248 x 2 in.

FACING PAGE: *Chapter Two "Giant,"* 2005. Acrylic and sumi on kumohadamashi paper mounted on wood panels, 86½ x 248 x 2 in.

In 2006, with *Chapter One*, Tomoko Konoike finally completed her spectacular four-part series of paintings begun two years earlier. The series started in reverse with *Chapter Four "The Return—Sirius Odyssey"* in 2004, followed by *Chapter Three "Wreck"* and *Chapter Two "Giant"* in 2005. Fans of her work awaited each installment with palpable anticipation, much as movie fans would wait for the next episode of *Star Wars*. This series, featuring grotesque fairytale landscapes painted in vivid colors on huge panels, is already widely considered a classic of Japanese contemporary art.

The strands of Konoike's complex and compelling narratives weave their way through a variety of media, including painting, sculpture, and video. With elements such as girls with red shoes, wolves, and knives, she acknowledges the influence of childhood fairy tales, but claims she simply paints images she finds aesthetically pleasing. "I have a really short attention span," she says, when asked about the surreal, fantasy elements that feature in her art. "I have to keep pouring interesting things into my work. Otherwise I would get bored with the creative process and I couldn't carry on."

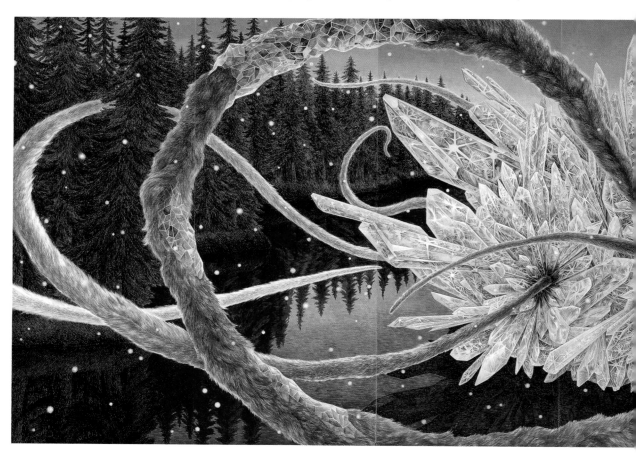

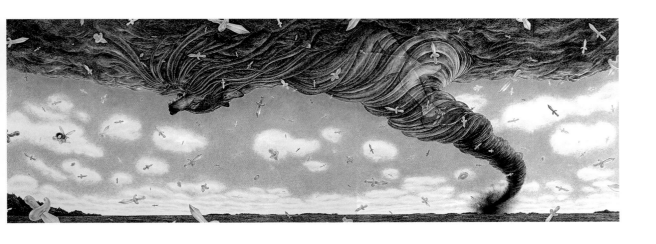

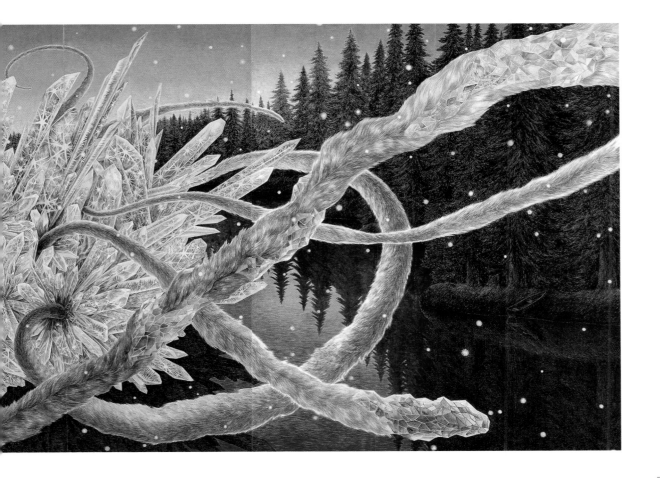

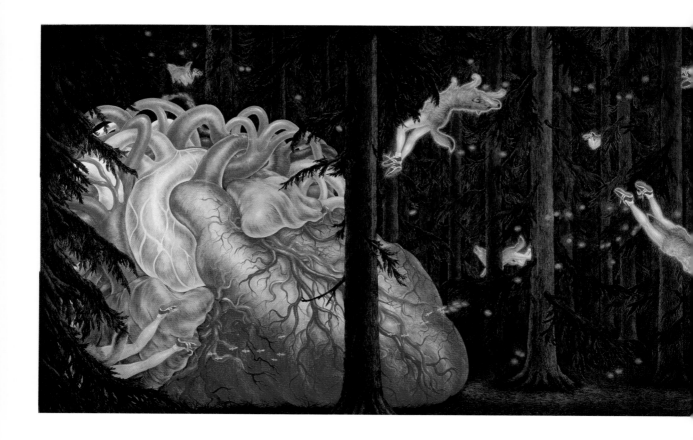

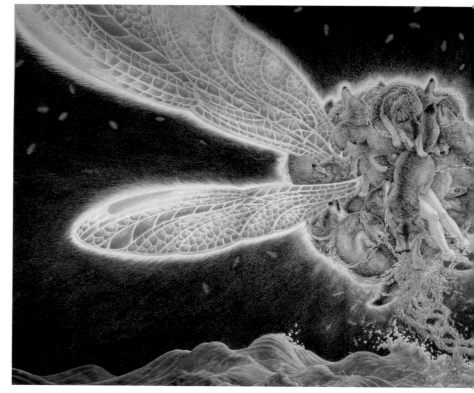

ABOVE: *Chapter Three "Wreck,"* 2005. Acrylic and sumi on kumohadamashi paper mounted on wood panels, 86½ x 248 x 2 in.

RIGHT: *Chapter Four "The Return—Sirius Odyssey,"* 2004. Acrylic and sumi on kumohadamashi paper mounted on wood panels, 86½ x 248 x 2 in.

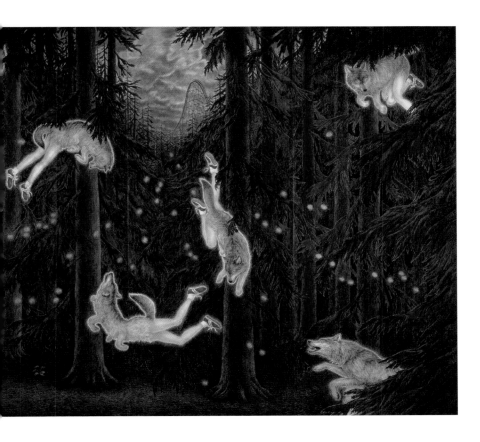

Mahomi Kunikata

Born 1979, Kanagawa Prefecture

The works of Mahomi Kunikata draw their influence from that pillar of otaku subculture, manga: in particular erotic, adult manga. She deals with serious themes such as self-abuse, depression, and abandonment, and expresses various complex emotions relating to her failed dreams of becoming a manga artist, her identity as an otaku, and her mixed feelings toward her family. But this negative personality has somehow managed to find acceptance as a fresh powerful force in the world of contemporary art.

In 2000, after graduating from the Graphic Design Department of Nippon Design School with a degree in illustration, Kunikata took part in the arts seminar Geijutsu Dojo (now known as GEISAI), a forum set up by Takashi Murakami to nurture fledgling artists.

Of the fifty-four artists who took part in the presentations and debates that made up this event, Kunikata was one of eleven invited to exhibit her work at the subsequent Geijutsu Dojo exhibition in Tokyo. Today she is a member of Murakami's production company Kaikai Kiki. At the December 2005 New Art Dealers Alliance (NADA) art fair in Miami, Kunikata mounted a solo exhibition at the Kaikai Kiki booth: a sushi bar installation *Maho Sushi*, featuring plastic pieces of sushi with erotic illustrations, a sushi-making video, a live painting event, and a display of drawings and canvas dolls from earlier in her career. The show was a sellout.

The erotic and grotesque expressions that are the cornerstone of Kunikata's work may well meet with censure in other countries, but in Japan they are tolerated. In that sense, Kunikata is a talent that could only have emerged in Japan. But although distinctly Japanese in expression, she gives voice to the brutal violence hidden inside us all.

THIS PAGE: *Pla Buk Featuring the Arts and Crafts Club,* 2006. Acrylic on canvas, 12½ x 16 in.

FACING PAGE: *Crayon,* 2004. Acrylic on canvas, 6 x 4 in.

THIS PAGE: *Sound of Body and Mind Freezing: The Story of Gyuui No. 4*, 2004. Acrylic and pencil on canvas, 64 x 51 in.

FACING PAGE: *Maho Sushi*, 2006. Acrylic on plastic food sample. Each piece approximately 1 x 4 in.

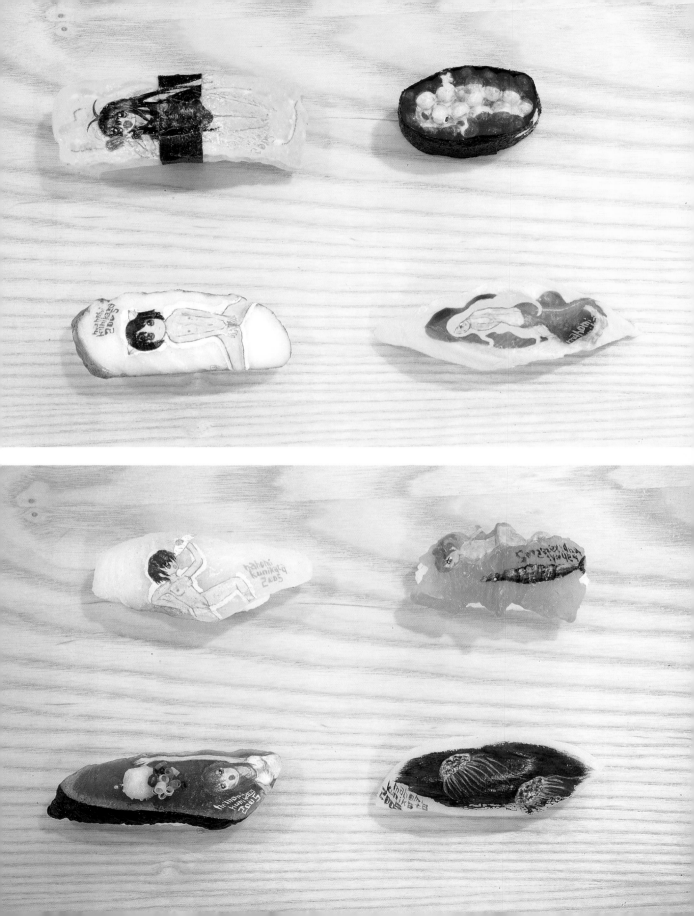

Masahiko Kuwahara

Born 1959, Tokyo

In 1996 an exhibition called TOKYO POP was held at Hiratsuka Museum of Art in Tokyo's neighboring Kanagawa Prefecture. Showing the works of sixteen artists, including Takashi Murakami, Yoshitomo Nara, Makoto Aida, and Maywa Denki, this exhibition drew attention to a group of Japanese artists sharing a similar "pop" sensibility three years before Takashi Murakami brought his "superflat" concept to the world. Of the artists in that group, Masahiko Kuwahara's large-scale paintings of toys made from petrochemical materials such as celluloid and vinyl left a particularly strong impression. Behind the artificial kitsch of these works lies a nostalgia for mass-produced toys that are doomed to be abandoned, coupled with a powerful sense of loss that stems from living in a society where things tend to quickly lose their importance and be thrown away. The theme of the dark emptiness of modern society is one that is central to his work. "There's a tired landscape spreading out in the contemporary world," says Kuwahara. "All my paintings are landscapes."

Kuwahara's later work depicts young girls and animals in vague, pastel tones. Seemingly attractive girls pose for the artist. Closer inspection, however, reveals that they are slightly deformed and imperfect. Dyed blonde hair sits awkwardly with their Asian features. In *Bitter Sea*, a girl clutches a flower and daintily crosses her legs, but her snout-like nose and indistinctly delineated limbs give her more than a passing resemblance to the pig at her side. Kuwahara seems to be commenting on the pressures society places on women to conform to certain standards of beauty by suggesting that the subservience that springs from the women's desire to appear attractive to the viewer is no different from the subservience of the dumb animals that sit next to them.

THIS PAGE: *Bitter Sea*, 2004. Acrylic on paper, 53 x 40 in.
FACING PAGE: *Bitter Sea*, 2004. Acrylic on paper, 53 x 40 in.

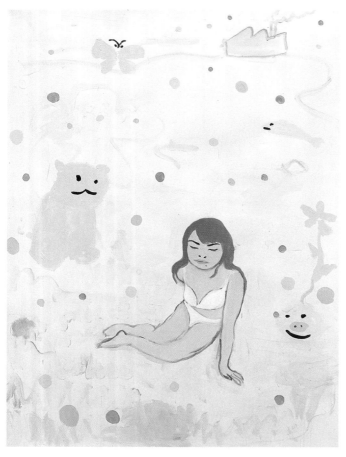

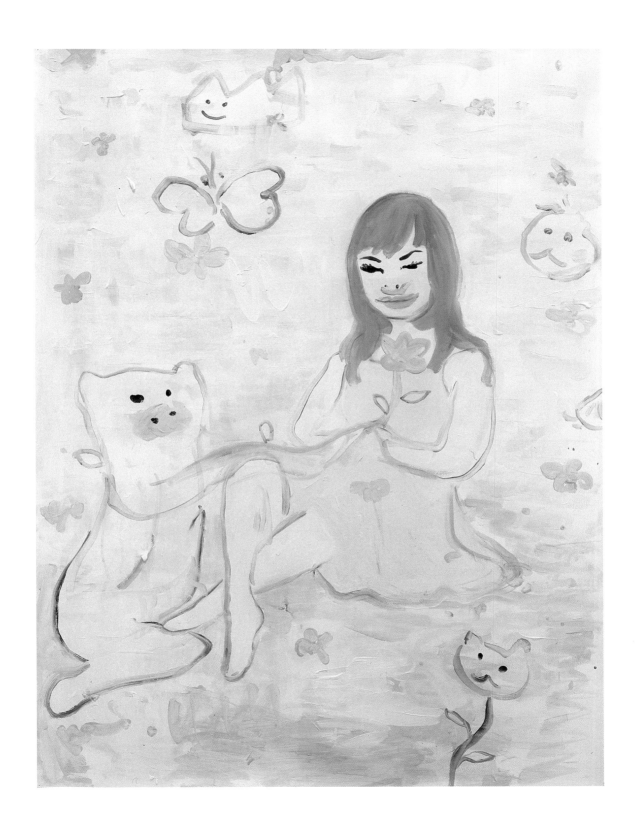

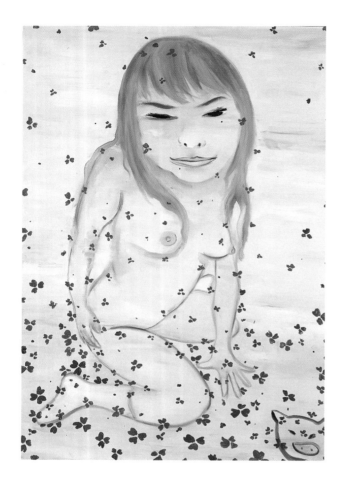

THIS PAGE, TOP: *Protean*, 2004. Oil on canvas, 51 x 35 in.

THIS PAGE, BOTTOM: *Purification—Brand-new City*, 2005. Oil on canvas, 46 x 36 in.

FACING PAGE: *Purification—Facility*, 2005. Oil on canvas, 46 x 36 in.

Kumi Machida

Born 1970, Gunma Prefecture

Kumi Machida works in ink, which she applies with delicate brushstrokes onto very thick, canvaslike, linen-based paper known as *kumohadamashi*. She uses traditional Japanese *nihonga* painting techniques, where the paper is coated with a base of animal glue before inks or powdered mineral pigments are applied, a delicate process that results in a picture of powerful intensity. Machida paints with an extremely thin brush and uses a mouthpiece to bite down upon as she grits her teeth. Each and every line she paints requires that much nervous tension and concentration.

A decadent mood reminiscent of the 1920s pervades her work, dating back to her first piece *Kozo* (Kid), featuring a tattooed Kewpie figure. A Kewpie doll with wings is clearly the very definition of cuteness, but the doll's body is covered with tattoos of traditional Japanese good luck symbols—a beckoning cat, a temple guardian dog, the chubby-cheeked good-luck figure known as Fukusuke, and a fox spirit—while the doll fixes the audience with a coquettish stare from under its long eyelashes. But is this a doll or a human? Male or female? Suddenly, we can't be sure. What we first thought was cute is now vaguely threatening. Looking at Machida's work is like looking at an optical illusion, and the distorted figures she depicts provoke a feeling of discomfort and anxiety in the viewer. In this way Machida skillfully combines traditional Japanese techniques and imagery with a very modern sense of malaise, particularly with regard to the human body.

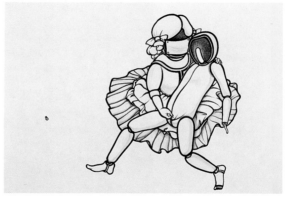

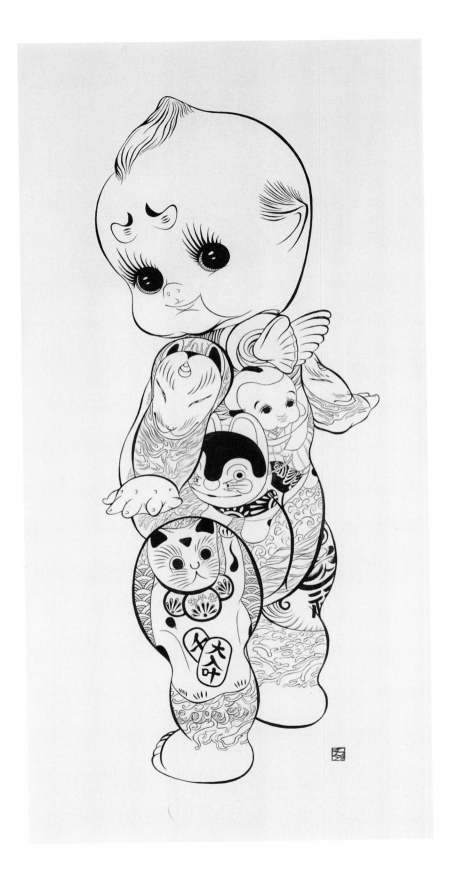

THIS PAGE: *Shonen shinsa*, 2003. Mineral pigment, ink, and gofun pigment on kumohadamashi paper, 11½ x 16½ in.

FACING PAGE: *Shu*, 2003. Mineral pigment, ink, and gofun pigment on kumohadamashi paper. 11½ x 16½ in.

Maywa Denki

Novmichi Tosa born 1967, Hyogo Prefecture

Maywa Denki is an art unit, founded in 1993 by brothers Masamichi and Novmichi Tosa, made to resemble a small family-run manufacturing business. It is actually named after a real company that used to be owned by their father. Artworks created by the unit are known as "products," and each exhibition or live performance is referred to as a "product demonstration." In 2001, company president Masamichi resigned from the corporation, and now younger brother Novmichi runs the concern on his own.

Maywa Denki has created various "product lines," including the *Naki* series based on fish-themed nonsense machines, the *Tsukuba* series consisting of strange musical instruments that are powered by motors or electricity, and

the *Edelweiss* series, which deals with the search for the ideal woman and whose themes are reproduction, flowers, surfaces, and fashion.

In 2006, Novmichi Tosa took over the *Edelweiss* product line from Maywa Denki and continued to develop it as one of his solo projects. *Edelweiss* is a complex science-fiction story set in a place called Tokyo on Weekends, or Matsu-kyo for short, a warped world where men have become weak and effeminate. Edelweiss is the mythical flower that will save the world. The product *Matsu-kyo Oil*, from this series, consists of phials of liquid made from about 150 drugstore products that can be applied to the body, such as shampoo and face lotion. Each phial has a flower-shaped lid, and looks like a pendant that could be hung from a necklace, but in fact it is a machine gun bullet. Novmichi Tosa's distorted take on life in the chaotic metropolis of Tokyo gives us a worrying inkling of the future.

THIS PAGE: *Matsu-kyo Oil*, 2000. ABS, glass, shampoo, facial tonic, each phial 2½ x ½ x ½ in.

FACING PAGE, TOP: *Guitar-la*, 1994. The guitars can be played by remote control through the pedal organ. Guitars, organ, aluminum, wood, 99½ x 92½ x 75 in.

FACING PAGE, BOTTOM: Still from the DVD *Maywa Denki no nansensu gakki* (Maywa Denki's Nonsense Instruments), 2005.

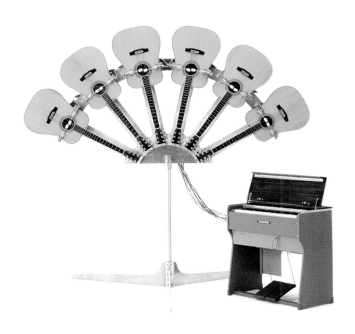

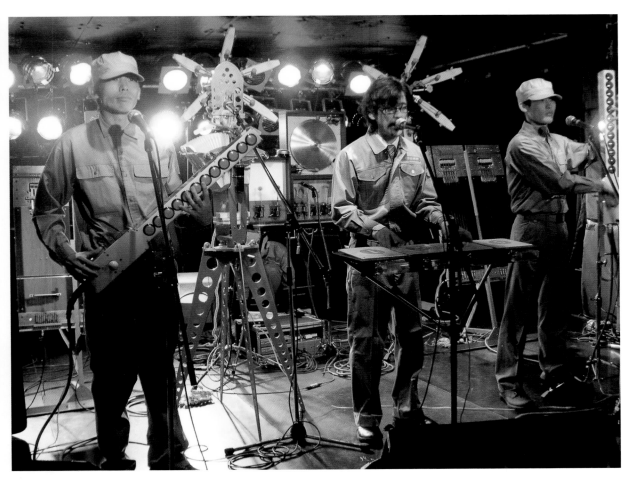

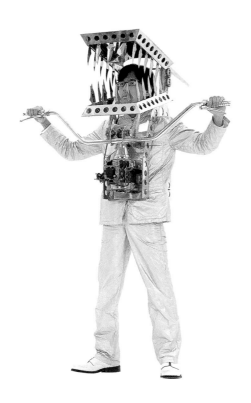

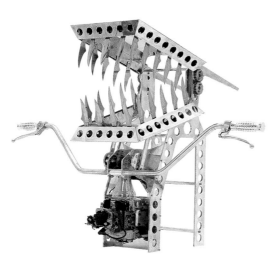

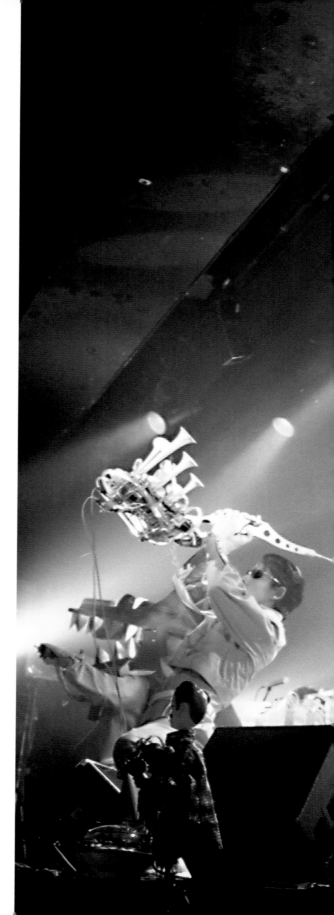

THIS PAGE, BOTTOM: *Poodles*, 2004. Engine-driven steel jaws with fangs of knives, to enable emasculated males to bite females to pieces. Aluminum, OHV36cc engine, 31 x 49½ x 30 in.

OPPOSITE: Maywa Denki live performance at Liquidroom, Tokyo, 2002.

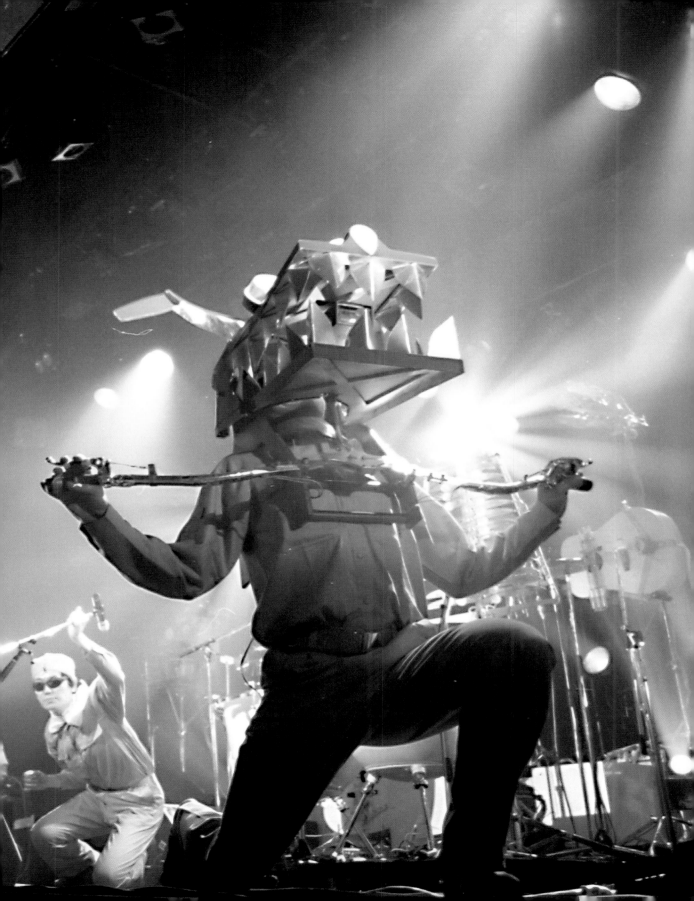

Mai Miyake

Born Kanagawa Prefecture

Originally an illustrator for Japanese magazines and books, in 2002 Mai Miyake made the decision to concentrate full-time on her career as a fine artist. Since then she has taken part in a great number of solo and group exhibitions, winning the Judges' Special Prize for her picture mounting at the 2003 Kyoto Amuse Project exhibition.

Miyake's work is noteworthy for the way in which it combines traditional Japanese forms of artistic expression, such as seasonal scroll paintings or folding screens, with a very contemporary sense of humor. In fact, "In rediscovering the old, we come to understand the new" is a well-known Japanese saying that might have been invented especially to describe the work of Mai Miyake, as she playfully mixes elements of the traditional and the modern.

In the *Kumade* series, for example, Miyake gives us her own humorous take on the traditional decorative bamboo pitchforks known as *kumade*. These pitchforks are good luck charms that are believed to bring prosperity to the owner and are sold at open-air stalls at shrines on festival days. Usually, *kumade* are decorated with traditional Japanese symbols of prosperity such as images of lucky gods, treasure ships, sea bream, or imitation gold coins, but Miyake's pitchforks bear very modern symbols of wealth: a Hermes bag, a computer game handset, a stock certificate.

Miyake's work is full of similarly mischievous elements. In *Tiger-zu* and *Dragon-zu*, the tiger and the dragon—animals that feature in many traditional scroll paintings—are clutching baseballs, a witty reference to two Japanese baseball teams, the Hanshin Tigers and the Chunichi Dragons. In *Wagashi saijiki* (A Glossary of Seasonal Japanese Confectionaries) she depicts sweets of the type that accompany the tea ceremony, in semi-three-dimensional form, using a blend of traditional and contemporary colors. These ever-present contemporary twists allow Miyake's work to blend seamlessly into a modern Japanese home or exhibition space while retaining a flavor of traditional Japan.

THIS PAGE: *Wagashi saijiki—The 12 Months,* 2004. Mixed media, 44 x 44 in.

FACING PAGE: *Tiger-zu/Dragon-zu—The Battle between the Tigers and the Dragons,* 2004. Mixed media, each scroll 23½ x 11 in.

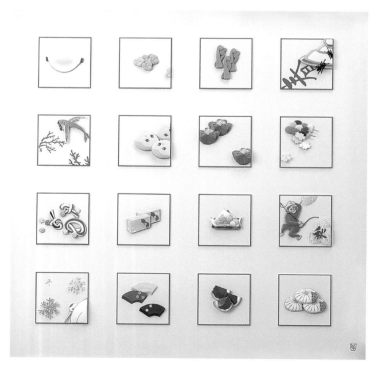

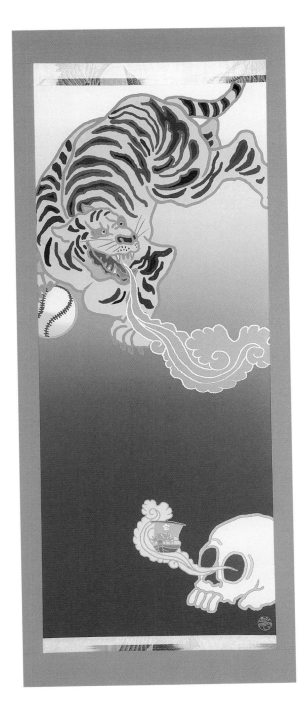

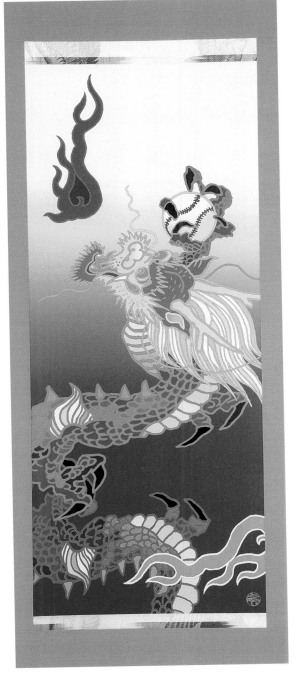

OVERLEAF, LEFT: *Kumade (PSP and tai)*, 2006.
Mixed media, 15 x 10½ x 4 in.

OVERLEAF, RIGHT: *Kumade (Hermes bag)*, 2006.
Mixed media, 27½ x 17½ x 6 in.

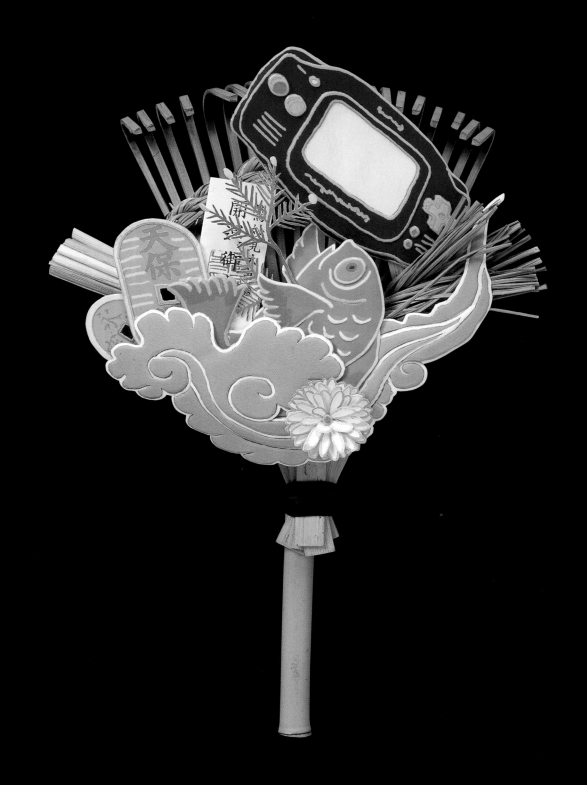

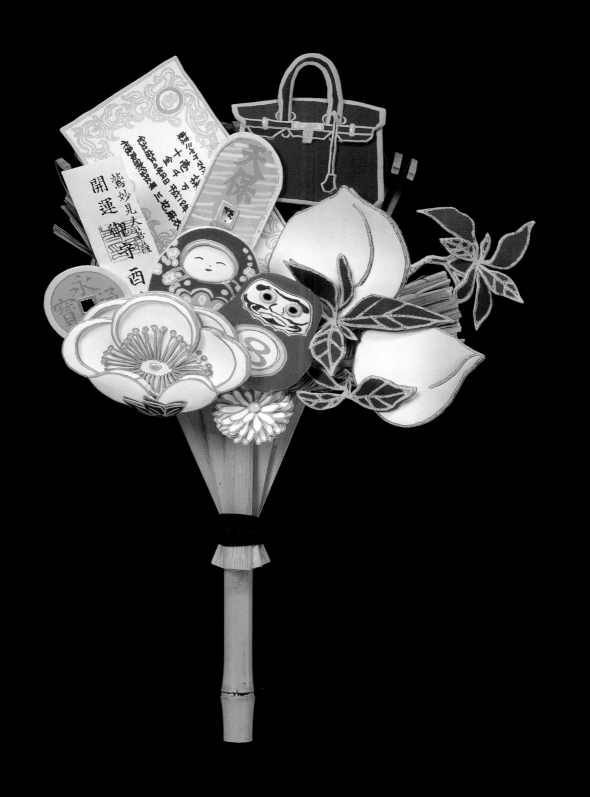

Shintaro Miyake

Born 1970, Tokyo

Shintaro Miyake graduated
from Tokyo's Tama Art Uni-
versity in 1996. He is an artist
who works in a wide variety
of media, including painting,
sculpture, and performance.
His signature character is
Sweet-san, a girl with long
limbs, pigtails, and a gigantic
head, who appears in his work
in various guises: a Minotaur,
an Imperial Storm Trooper
from *Star Wars*, or a fluffy cloud in a
blue sky. Sweet-san is usually rendered
on cardboard or wooden cutouts, but
when Miyake himself dresses up in a
Sweet-san costume for live painting
sessions, the character comes to life
and a powerful communication takes
place between artist and audience.

Dressing as the characters who
appear in his works, in costumes that
he makes himself, is one of Miyake's
well-known trademarks. The Beaver

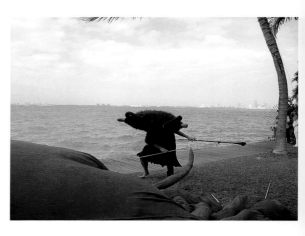

THIS PAGE, TOP: *Minotaur vs Kraken*, 2005.
Inkjet print mounted on Plexiglas,
7½ x 10 in.

THIS PAGE, BOTTOM: *Cavalry*, 2005. Color
pencil and acrylic on cardboard on wood,
82½ x 115 x ½ in.

FACING PAGE: Installation view, Tomio
Koyama Gallery, Tokyo, 2005.

Project exhibition that was held in
Boston in 2006 saw him take part in a
live drawing session that covered thirty
feet of wall over a period of three days,
and star in a nature documentary film
dressed as a beaver, collecting wood
and building a house.

Miyake's Atsumori exhibition, held
in 2005 at the Tomio Koyama Gallery
in Tokyo, was inspired by paintings of
warriors and battle scenes from Japan's
Heian period (794–1185), and particu-
larly by the story of the teenage mili-
tary commander Taira no Atsumori
(1169–84) who was killed by Naozane
Kumagai of the rival Minamoto clan
during the Battle of Ichinotani during
the Genpei War (1180–85). Legend
has it that Kumagai wanted to spare
the boy because his youth and beauty
reminded him of his own son. This
poignant story is still popular in Japan
today, and is often reenacted in noh,
kabuki, and bunraku drama.

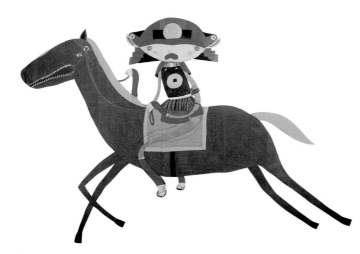

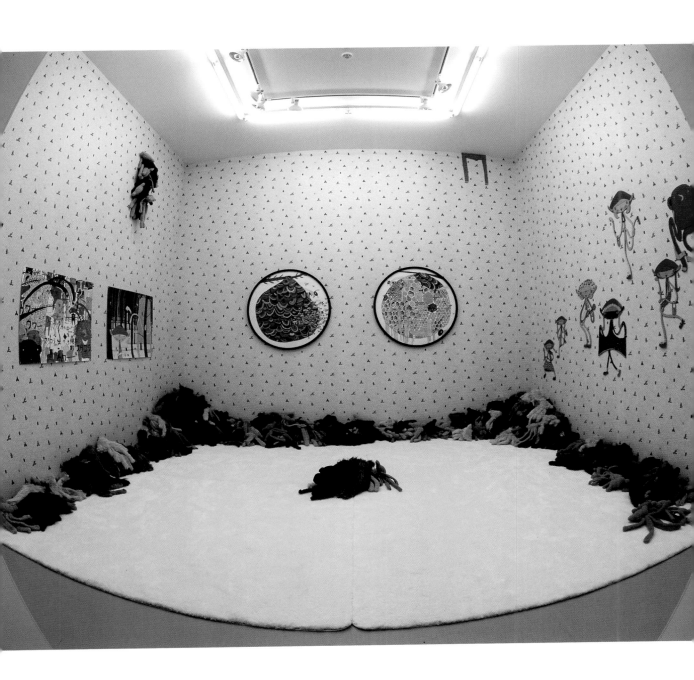

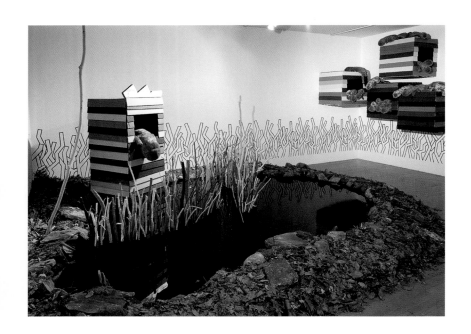

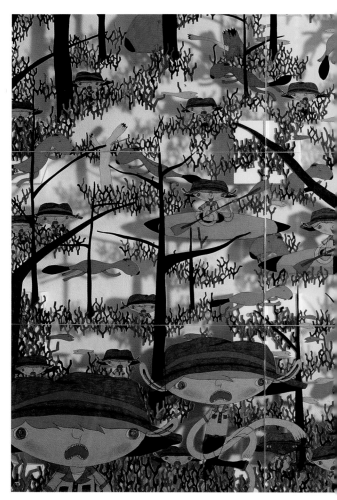

THIS PAGE, TOP: The Beaver Project. Installation view, Sandra and David Bakalar Gallery at Massachusetts College of Art, Boston, 2006.

THIS PAGE, BOTTOM: *Beaver-ko*, 2006. Color pencil and pencil on cardboard and Plexiglas, 65 x 127 in.

FACING PAGE, TOP: Atsumori. Installation view, Tomio Koyama Gallery, Tokyo, 2005.

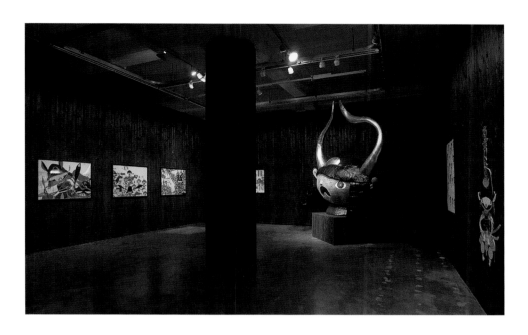

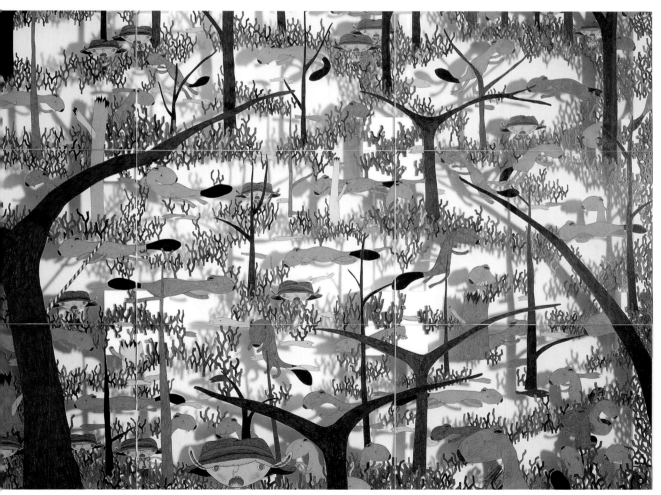

Junko Mizuno

Born 1973, Tokyo

Junko Mizuno draws on the cute characters found in girls' comics and incorporates them into her own narrative world—a place where fantasy meets grotesque. The sweet-looking girls in her illustrations are depicted against an incongruous backdrop of blood, knives, drugs, and sex, and it is this very contemporary reflection of a society in chaos that has attracted so many fans to Mizuno's work.

In addition to her work as an illustrator, Mizuno is a successful manga artist. Her publications such as *Hell Babies*, *Pure Trance*, and *Cinderalla* are popular overseas as well as in Japan.

Mizuno's characters are clearly delineated with simple curved lines, which ought to make her pictures appear flat, but instead, the glamorous girls and assorted cute creatures that inhabit her pictures appear to jump out of the frame. The illusion of depth is further enhanced by her use of color, with subtle gradations of red, pink, and orange beckoning us ever deeper into her world. Although "grotesque" is a word often used when describing Mizuno's art—and the grotesque elements in her work rank alongside the most grotesque of grotesque Japanese manga—it is sometimes easy to ignore this, lulled into a false sense of security by her elegant use of line and color. In a world overflowing with representations of the grotesque, Junko Mizuno is surely its most refined exponent.

THIS PAGE: *Pine tabidachi*, 2002. Digital.
FACING PAGE: *Keiko Yamazaki* from the manga *Pure Trance*, 1998. Pen on paper.

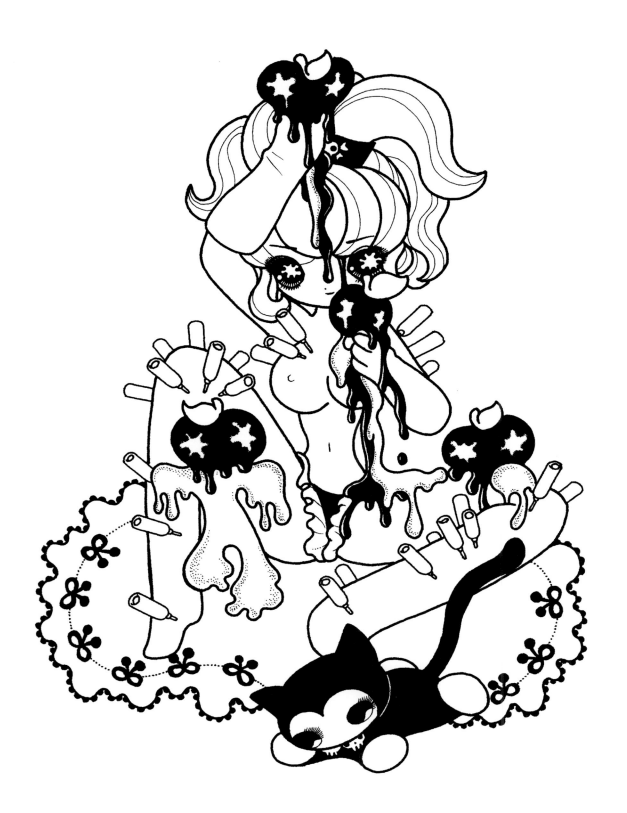

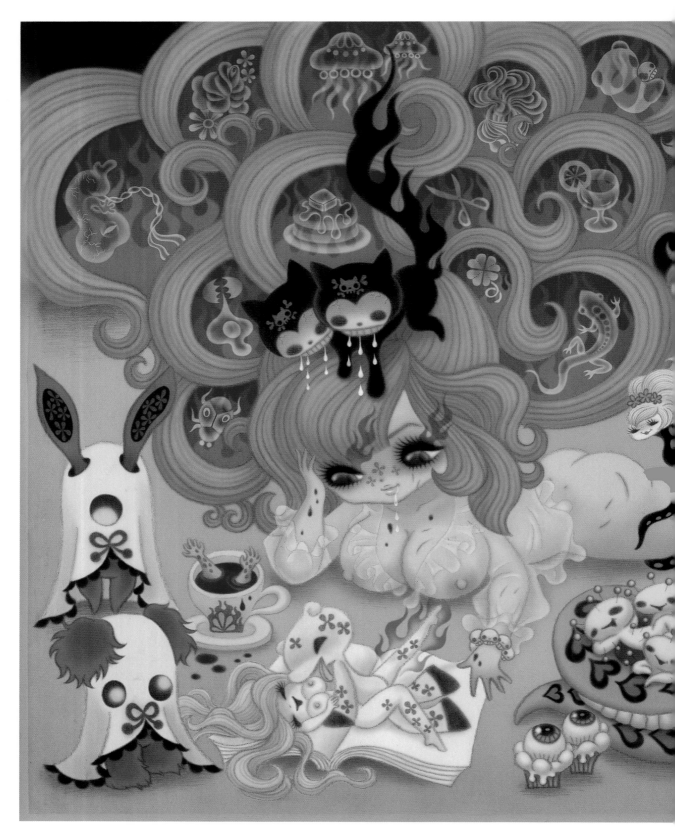

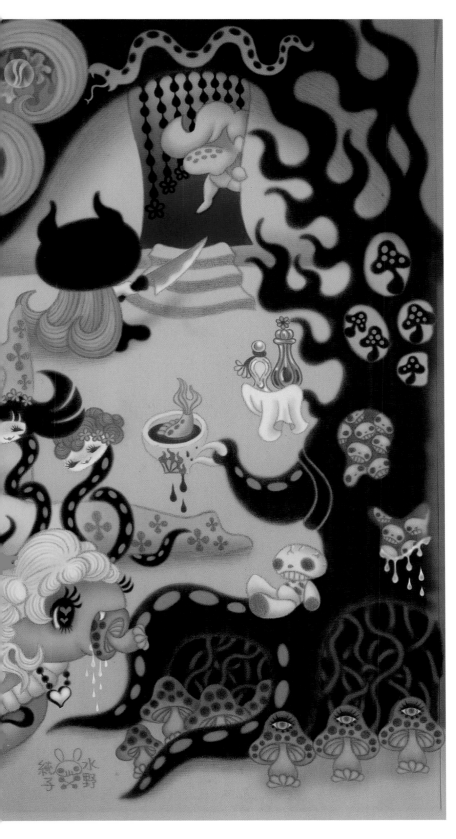

Yoneko's Tea Party, 2006. Digital.

Yasumasa Morimura

Born 1951, Osaka

Since 1985, when he created a large-scale photographic work in which he portrayed himself dressed as Vincent Van Gogh, Yasumasa Morimura has continued to use self-portraits as his means of artistic expression. He has won worldwide renown for works such as the series *Art History* (1990) in which he casts himself as the central figure in photographic recreations of famous Western works of art such as the *Mona Lisa* and Manet's *Olympia*, and the series *Actress* (1995) in which he photographs himself dressed as Western film stars such as Marilyn Monroe and Audrey Hepburn. Critics are intrigued by the issues of

gender and postcolonialism that come into play when an Asian man takes on the guise of an iconic Western woman.

Taking a new direction, Morimura's 2006 series *Seasons of Passion/A Requiem: Chapter 1* recreates news photographs and footage of historic events in the twentieth century, including the work of several Pulitzer prize winning photographers: Yasushi Nagao's 1960 photograph of the fatal stabbing of Japanese socialist party leader Inejiro Asanuma, Eddie Adams' 1968 photograph of the execution of Viet Cong prisoner Nguyen Van Lem, and Robert H. Jackson's photograph of Jack Ruby shooting Lee Harvey Oswald in 1963. Morimura plays every character in these scenes. The series also includes a recreation of a still from television footage of the suicide in 1970 of Yukio Mishima, a writer much admired by Morimura.

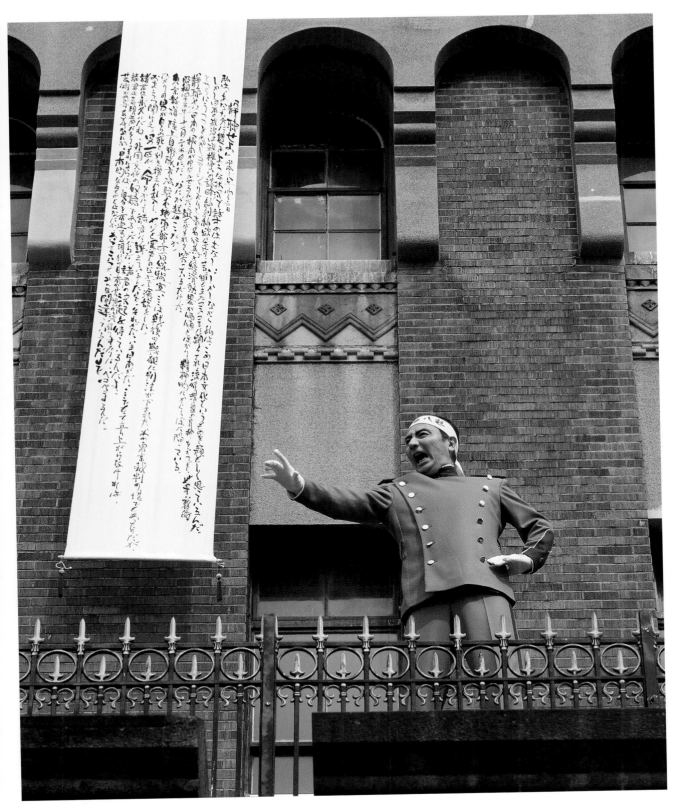

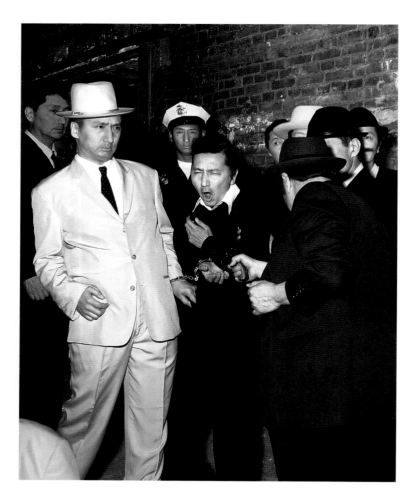

THIS PAGE, TOP: *A Requiem: OSWALD, 1963.11.24–2006.4.1*, 2006. Gelatin silver print, 59 x 47 in.

THIS PAGE, BOTTOM: *A Requiem: ASANUMA 2, 1960.10.12–2006.4.2*, 2006. Gelatin silver print, 29½ x 59 in.

FACING PAGE: *A Requiem: VIETNAM WAR 1968–1991*, 2006. Gelatin silver print, 47 x 59 in.

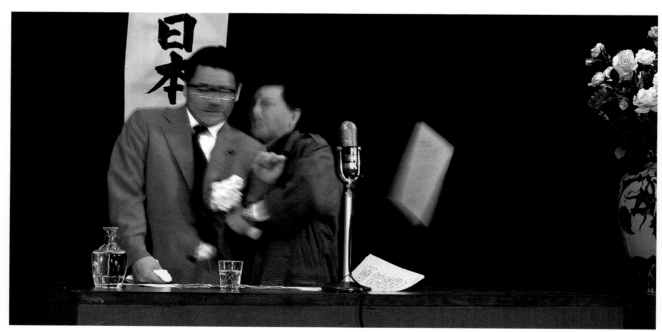

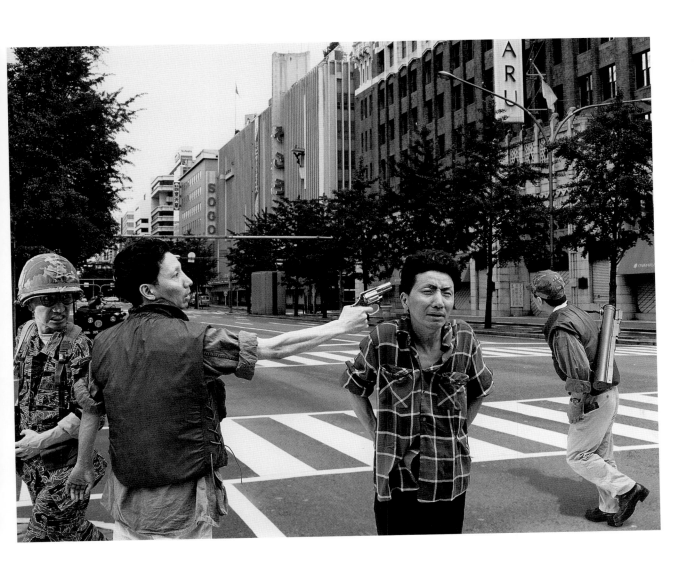

Hisaharu Motoda

Born 1973, Kumamoto Prefecture

Hisaharu Motoda is regarded by many as one of the rising stars in the world of printmaking, having won several major prizes since obtaining a master of fine art degree in 2001 from the Tokyo National University of Fine Arts and Music, where he now works as a teacher. His fame is spreading not only in his native Japan, but also overseas, where he has taken part in exhibitions in countries as diverse as Egypt, Canada, and Thailand.

In his *Neo-Ruins* series, Motoda depicts a postapocalyptic Tokyo, where familiar landscapes in the central districts of Ginza, Shibuya, and Asakusa have been reduced to ruins and the streets are eerily devoid of humans. The weeds that have sprouted from the fissures in the ground seem to be the only living organisms. "In *Neo-Ruins* I wanted to capture both a sense of the world's past and of the world's future," he explains.

Motoda's view of the future at first seems nihilistic, but the proliferation of plant life in the ruined streets seems to suggest that there are other ways for the planet to survive even after our great cities have fallen.

BELOW: *Indication—Shibuya Center Town*, 2005. Lithograph, 27½ x 45 in.

FACING PAGE: *Indication—Ginza Chuo-dori*, 2005. Lithograph, 26 x 31 in.

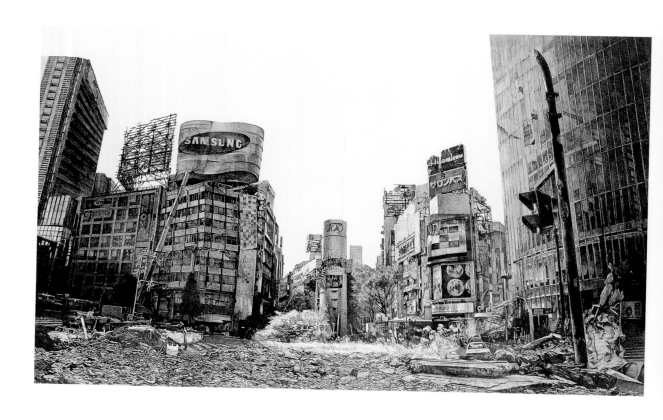

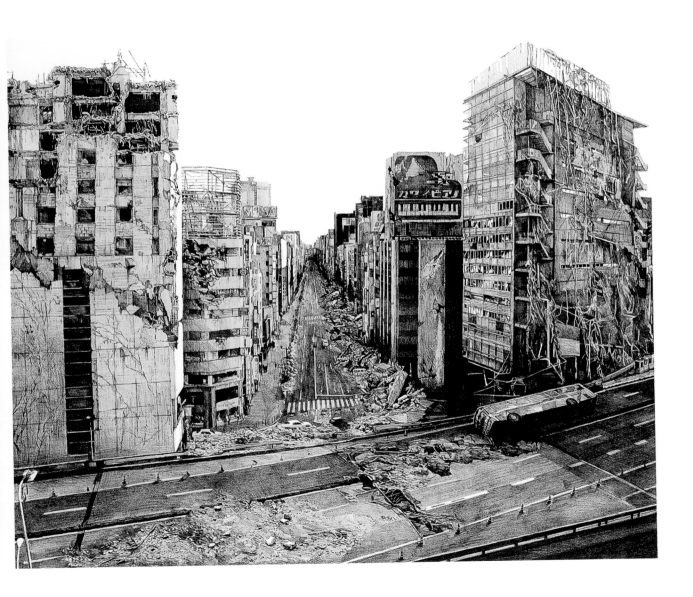

93

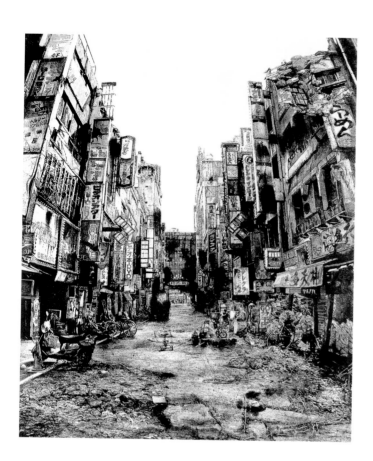

THIS PAGE, TOP: *Revelation—Kabukicho*, 2004. Lithograph, 24 x 19½ in.

THIS PAGE, BOTTOM: *Revelation—Asahi Breweries Building*, 2004. Lithograph, 22 x 30 in.

FACING PAGE, TOP: *Indication—Kaminarimon*, 2005. Lithograph, 19½ x 29 in.

FACING PAGE, BOTTOM: *Indication—Ginza 4-chome Intersection*, 2005. Lithograph, 28½ x 45 in.

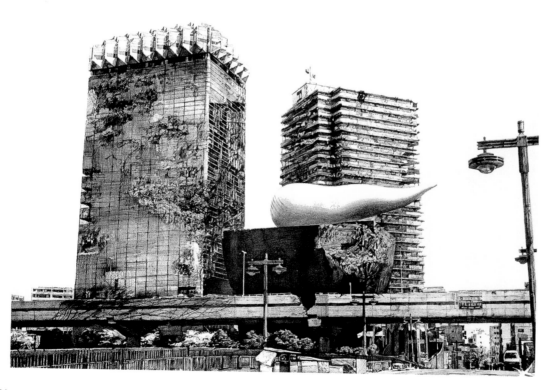

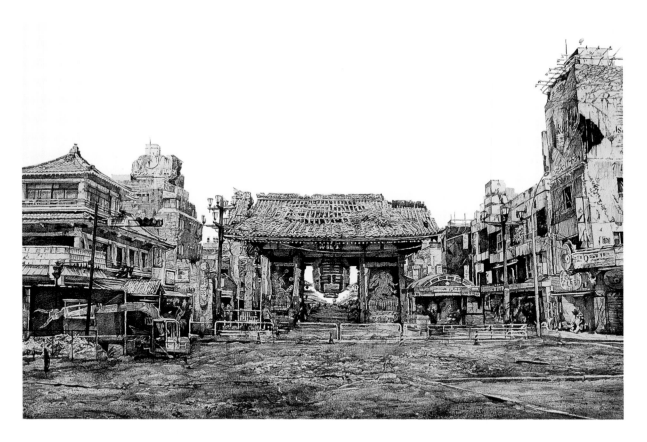

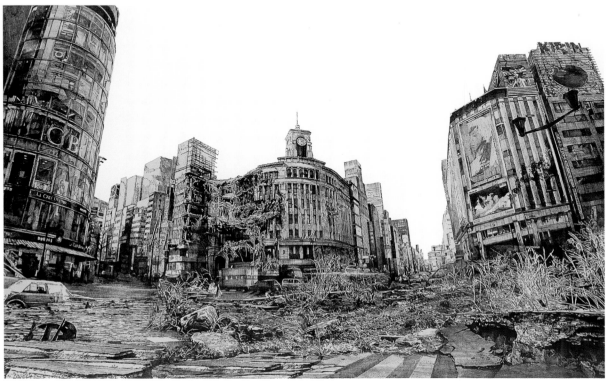

Mr.

Born 1969, Cupa

In 1995, Mr. joined the Hiropon Factory (now called Kaikai Kiki), the production company set up by Takashi Murakami to nurture young artists and promote his own artwork. Since then, Mr. has become one of Murakami's leading disciples.

His first solo show was in 1998, held at Tokyo's Tomio Koyama Gallery and entitled Mr.—Artist of the Alps. This exhibition attracted attention not just because many of the exhibits were pictures that Mr. had drawn on the back of convenience store and supermarket receipts that he had hoarded over the years, but also because the main subject matter of his works was young girls. The title of the exhibition was inspired by the TV anime *Heidi: Girl of the Alps*, which he loved watching as a child, and which features the type of pretty young girl idealized by Japan's otaku or "geek" culture. The sexualization of young girls in manga and anime is referred to as *rorikon* (short for "Lolita complex") in Japan, and is a theme often explored in Mr.'s work.

Rumor has it that Mr. creates his work mumbling, "When I die, I don't want to go to Heaven, I want to go to Akihabara." Akihabara is the Tokyo district crammed with maid cafés, and stores selling manga, video games, plastic figures of anime characters, and other otaku goods. Mr.'s dream of an otaku paradise is often seen in the gigantic eyes of the figures he creates, where happy young people are reflected against utopian scenes of blue skies or moonlit evenings.

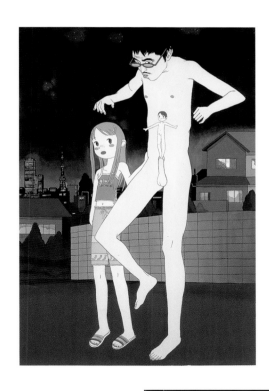

Takashi Murakami

Born 1962, Tokyo

THIS PAGE, LEFT: *And Then, And Then And Then And Then And Then (Blue)*, 1996. Acrylic on canvas mounted on board, 118 x 118 in.

THIS PAGE, RIGHT: *Tan Tan Bo Puking—a.k.a. Gero Tan*, 2002. Acrylic on canvas mounted on board, 141½ x 283½ x 2½ in.

FACING PAGE, TOP LEFT: *Reversed Double Helix*, 2003. Urethane paint, fiberglass and steel.

FACING PAGE, TOP RIGHT: *The Emperor's New Clothes*, 2005. Fiberglass, resin, oil paint, lacquer, acrylic plates, fabric, iron, and wood, 74½ x 43 x 40 in.

With his highly acclaimed three-part series of exhibitions, Superflat (2000), Coloriage (2002), and Little Boy (2005), that have shown all over the world, Takashi Murakami has brought an awareness of Japanese pop culture to an international audience. One of his objectives is to flatten out the boundaries between the type of manga and anime inspired "low" art made popular by many contemporary Japanese artists, and more traditional Western-style fine or "high" art.

Murakami's work features cartoon-like characters such as the Mickey Mouse-like Mr. DOB who appears in a variety of distorted forms. Although the character is cute, the name DOB is an abbreviation of the catchphrase of Japanese comedian Toru Yuri, *doboshite*,

slang for "why," perhaps to question the importance of cute in Japanese popular culture.

Despite the apparent simplicity of much of his work, Murakami displays a high level of technical accomplishment. For example, to achieve the flatness that is a characteristic of his paintings, he applies forty layers of paint, which he then polishes down to achieve the correct texture. He is just as meticulous with color, using between seventy and one hundred and fifty colors in a typical painting. Murakami's attention to detail even encompasses the titles of his works, which are chosen not just for their meaning but for their sense of rhythm.

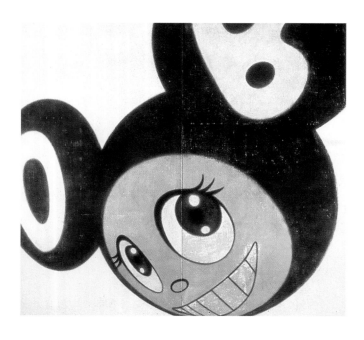

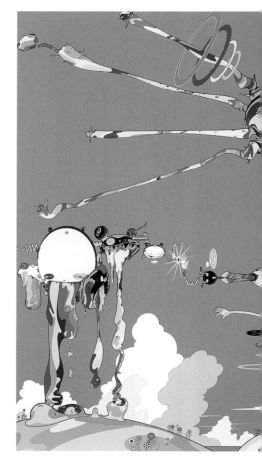

100

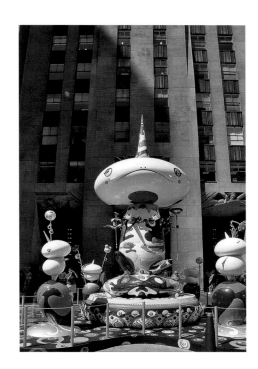

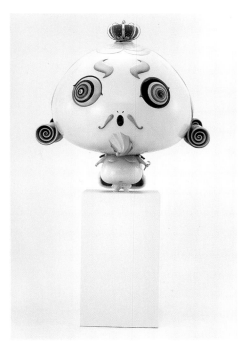

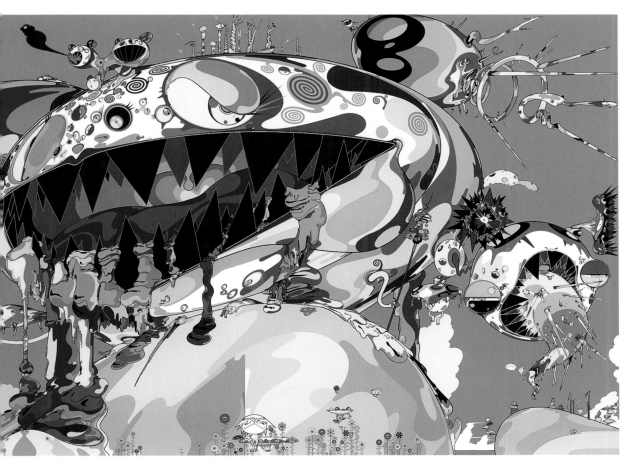

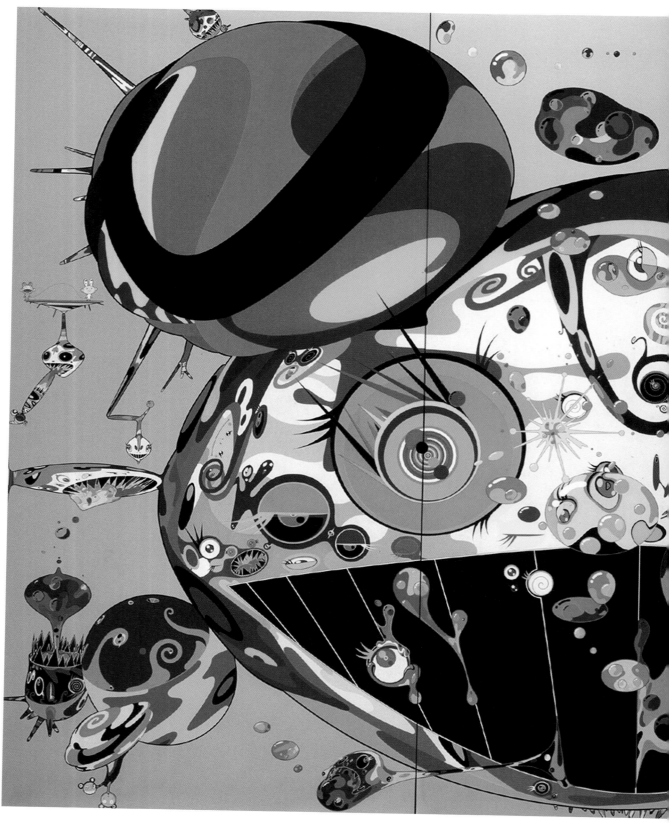

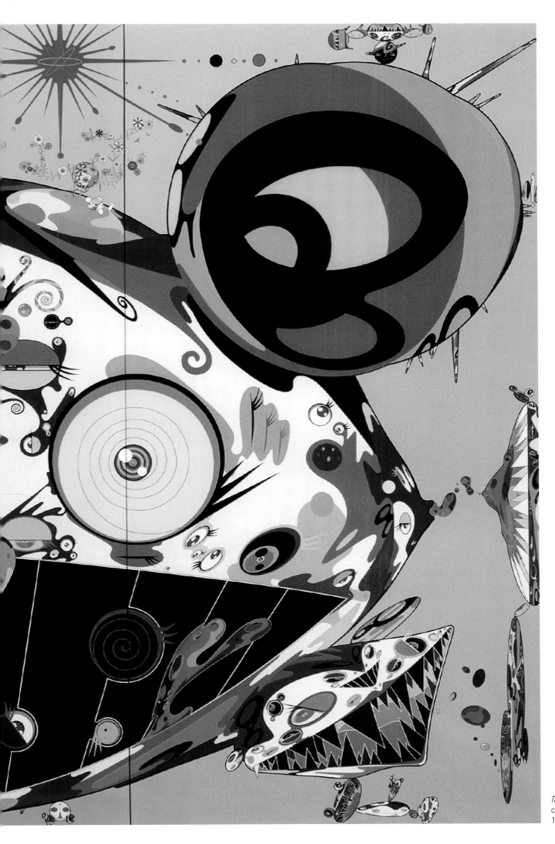

Tan Tan Bo, 2001. Acrylic on
canvas mounted on board,
141½ x 212½ x 2½ in. (3 panels).

Kengo Nakamura

Born 1969, Osaka

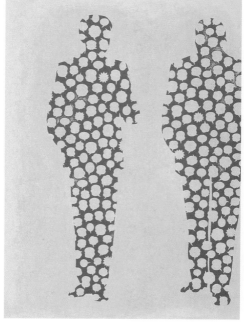

Kengo Nakamura's *Speech Balloon* series is a work of social satire in which ordinary people and great works of art, such as Ingres' *The Source* and Matisse's *Dance*, are rendered in manga-style speech balloons. The speech balloons are all empty, as though to say that most of our everyday conversational interactions are of little substance.

In *Composition Tokyo*, Nakamura paints floor plans of tiny Japanese apartments in the style of Mondrian, giving a powerful sense of the anonymity and isolation of the people who live in these rooms. This theme continues in the series *Without Me*, where the vague silhouettes seem to suggest that in big cities like Tokyo we tend to perceive the crowds of people rushing past us as shadowy entities without personality, rather than real flesh and blood beings.

With his bright colors and manga-like imagery, Nakamura would appear to be the quintessential Japanese pop artist, yet his works are rooted in traditional *nihonga* Japanese painting techniques, using mineral pigments on Japanese paper. With care, paintings using these natural ingredients can last for hundreds of years. Kengo Nakamura's reflection of contemporary Japanese society is one that may well be passed down through future generations as a historical document.

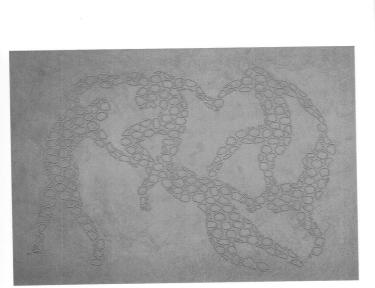

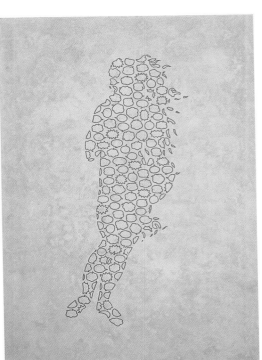

THIS PAGE AND FACING PAGE: *Without Me*, 2006. Mineral
pigment and pigment on Japanese paper, 57 x 38 in.

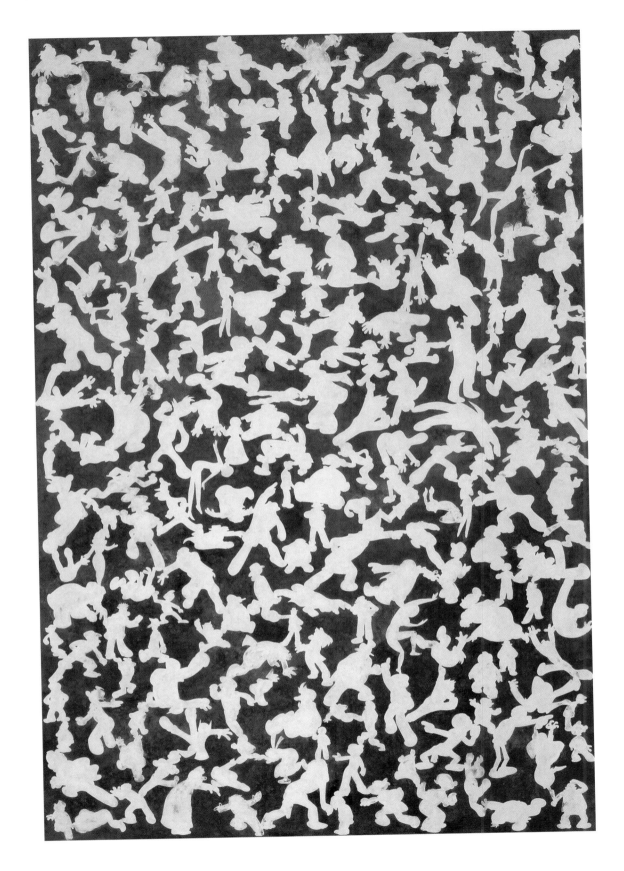

Yoshitomo Nara

Born 1959, Aomori Prefecture

In 2001 Yoshitomo Nara's exhibition I Don't Mind If You Forget Me opened at the Yokohama Museum of Art. For a relatively young artist to hold a solo exhibition at a public art museum was confirmation of Nara's position, alongside Takashi Murakami, at the forefront of Japanese contemporary art.

Nara's trademarks are his angry or troubled little girls, marooned against an empty background, excluded from the adult world. Later works have a softer, less aggressive feel, with hints of the outside world beautifully reflected in the girls' large eyes, but the sense of melancholy and isolation is unchanged.

It is not just the theme of youthful alienation that has attracted a young audience to Nara's work. His love of rock and punk, and collaborations with various musicians, have won him many fans outside the traditional art sphere.

In 2003 Nara began a series of exhibitions with the team from Osaka-based creative unit "graf," where the art was displayed in huts rather than in a gallery. This series culminated in 2006 with the exhibition A to Z in Nara's hometown of Hirosaki in northern Japan, featuring the work of nine artists in over forty huts. What made this exhibition special was that volunteers helped to make the huts, a revolutionary new method of artistic collaboration. "I value freedom above all else," says Nara. "I always want to be free from everything, and I like people around me to be free as well. In this sense I am delighted that people from Hirosaki and from all over Japan came together of their own free will to take part in this project."

THIS PAGE: *Seoul House.* Installation, Rodin Gallery, Seoul, 2005.

FACING PAGE: *The Little Star Dweller,* 2006. Acrylic on canvas, 89½ x 71½ in.

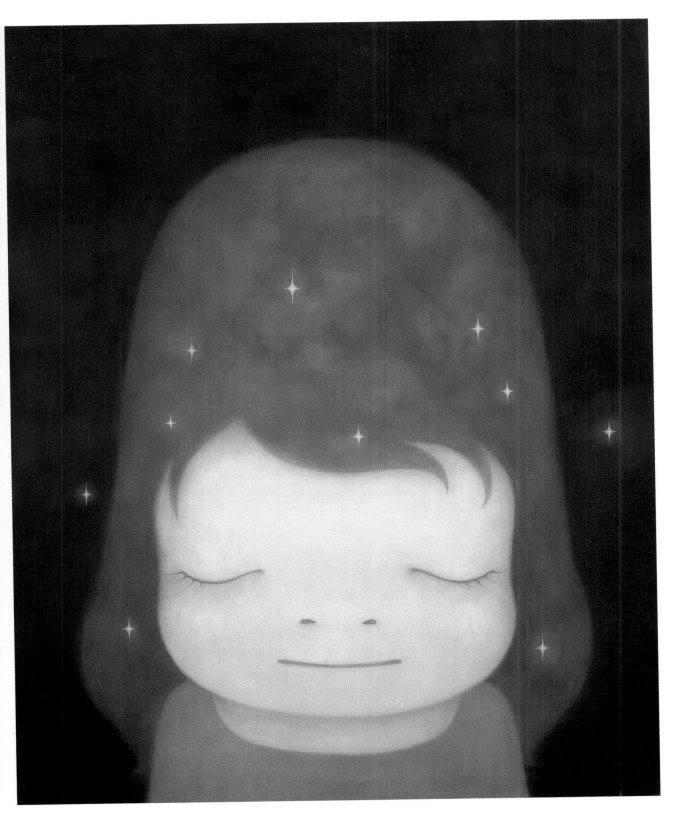

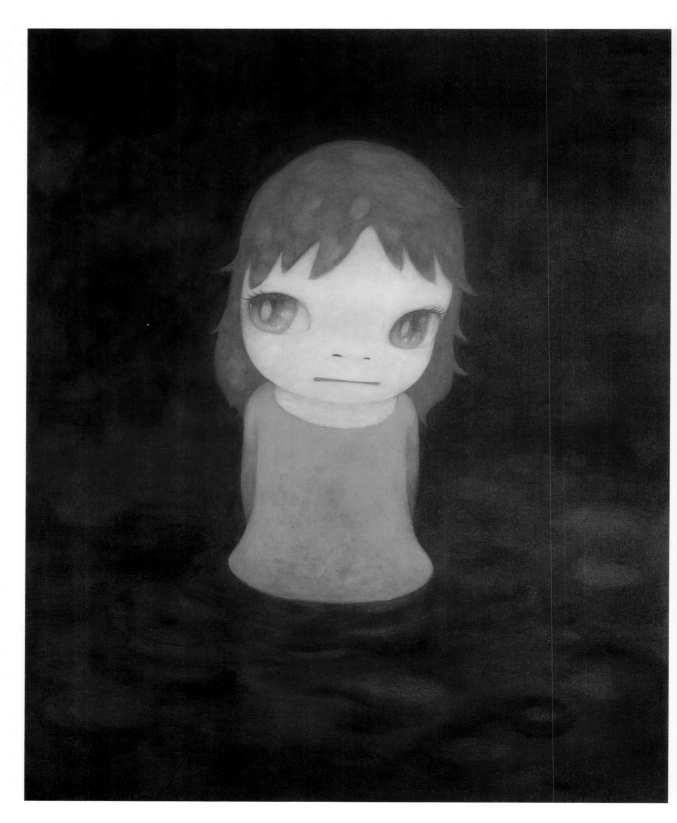

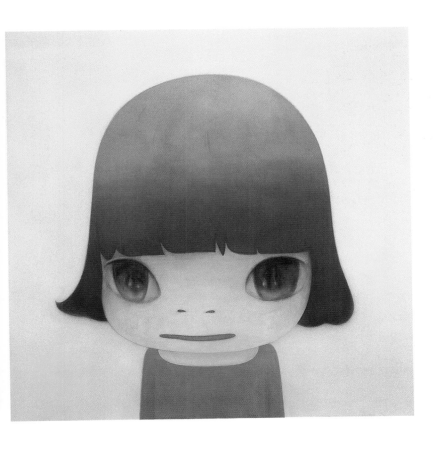

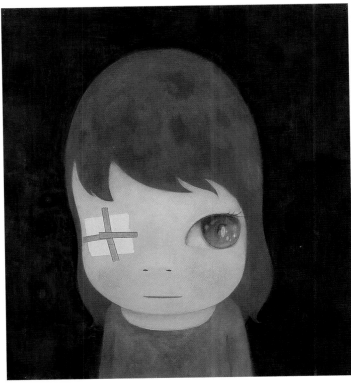

FACING PAGE: *After the Acid Rain*, 2006. Acrylic on canvas, 89 x 71½ in.

THIS PAGE, TOP: *Agent Orange*, 2006. Acrylic on canvas, 64 x 64 in.

THIS PAGE, BOTTOM: *Sorry, Couldn't Draw Right Eye*, 2005. Acrylic and collage on paper, 59 x 55 in.

Yasuyuki Nishio

Born 1967, Tokyo

Yasuyuki Nishio works using a variety of techniques, from painting with ink or oils, to sculpture. He is probably the only sculptor in the world using a technique known as *inkoku chuzo* in Japanese, which roughly translates as "hollow relief casting." In this process, plaster is poured into a clay mold that the artist has sculpted by hand. Whereas most works of sculpture are formed from the outside in, Nishio's works are made from the inside out, and the finished piece bears the traces of his fingerprints and hand movements. Hollow relief casting is believed to date from Japan's Yayoi period (approximately 300 BC to AD 300), when it was used to make a type of bronze bell known as *dotaku*.

An outstanding example of Nishio's work in this medium is a massive sculpture of Sayla Mass, heroine of popular Japanese anime series *Gundam*. The sculpture, which filled a whole room, was made for the *Gundam* tribute art exhibition Gundam: Generating Futures, held in Tokyo in 2005, in which twenty-three artists paid homage to the legendary science fiction phenomenon.

When Nishio was a child, he accidentally found the corpse of a person who had committed suicide, and he also discovered a rotting corpse as an adult. This unusual coincidence may have led to a preoccupation with the ephemerality of life, a theme that is often reflected in his work. Although a grotesque piece such as *Tanatosis*, featuring corpses wearing the latest fashions, may make us laugh, it ultimately serves to remind us of our mortality.

THIS PAGE: *Tanatosis*, 2004. Light clay, oil paint. 10½ x 26 x 4½ in. (case size).

FACING PAGE: *Fight for the Cause of Justice (Skin)*, 2002. Ink on Chinese paper on hanging scroll, each scroll 78 x 32 in.

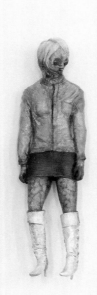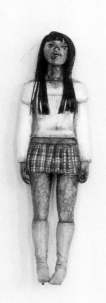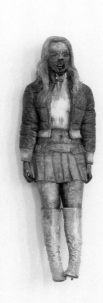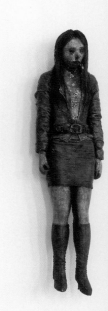

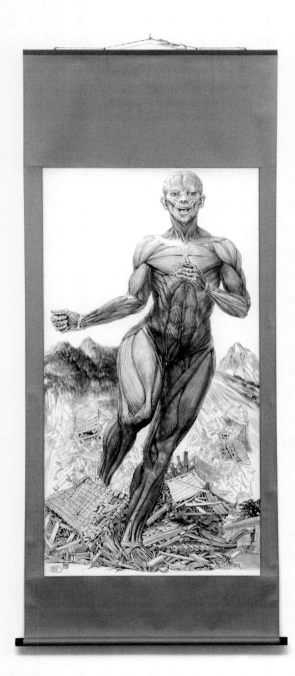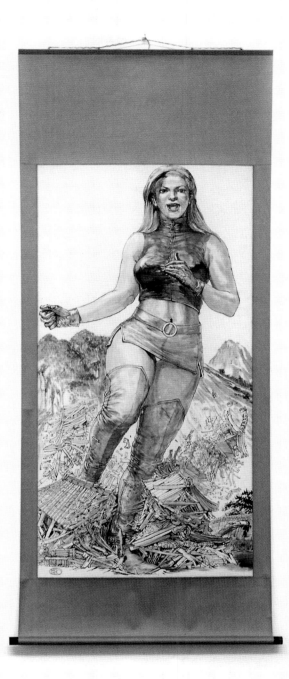

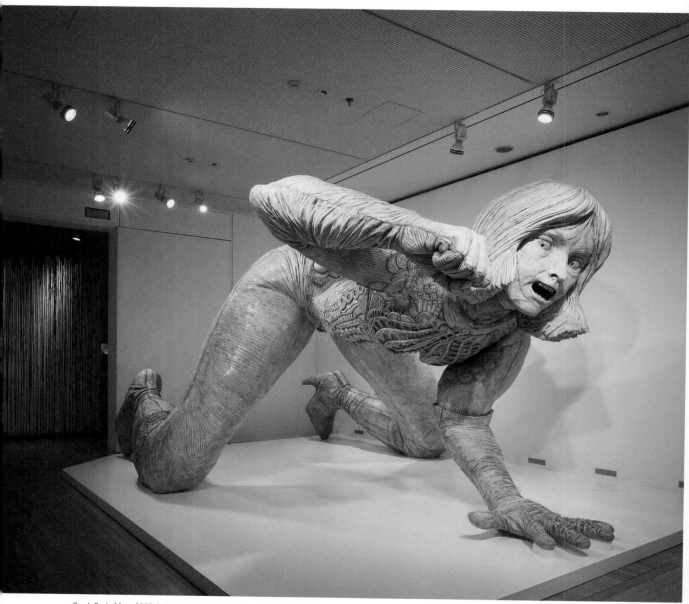

Crash Sayla Mass, 2005. Negative cast, fiber plaster, 110 x 157½ x 236 in.

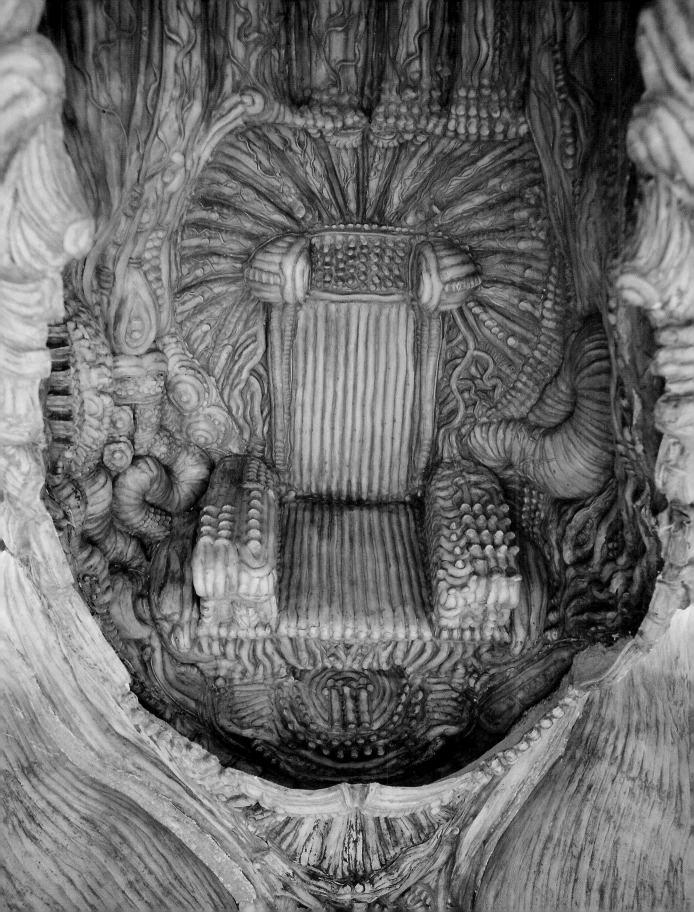

Motohiko Odani

Born 1972, Kyoto

Motohiko Odani drew a great deal of attention to the Japan Pavilion when he took part in the 50th Venice Biennale in 2003, enchanting visitors with works such as *Berenice*, a spaceship with the feeling of a living organism that might have come straight out of a science fiction anime, and *Rompers*, a fantasy-horror audio-visual piece. Critics have attributed the grotesque elements in his work to the influence of science fiction and horror movies.

A graduate of the Sculpture Department of the prestigious Tokyo National University of Fine Arts and Music, Odani works in sculpture, video, and photography. Since his debut in 1995, he has continually strived to make his art more than simply an "object" to be looked at. His installation *9th Room*, shown in 2001, was a room in which a video of a waterfall was projected onto all four walls and the floor and ceiling, an example of a work of art that spreads out to encompass the whole of the exhibition space and the audience too. It was a work that brought to life the sensation of experiencing something for the very first time. The theme of the relationship between bodily experience and surroundings is one that is also reflected in Odani's digital animation work *Jackal*, in which isolated characters in a bleak and hostile environment are preoccupied with the most basic bodily functions necessary for survival.

Berenice, 2003. FRP, steel, other media, approximate diameter 118 in.

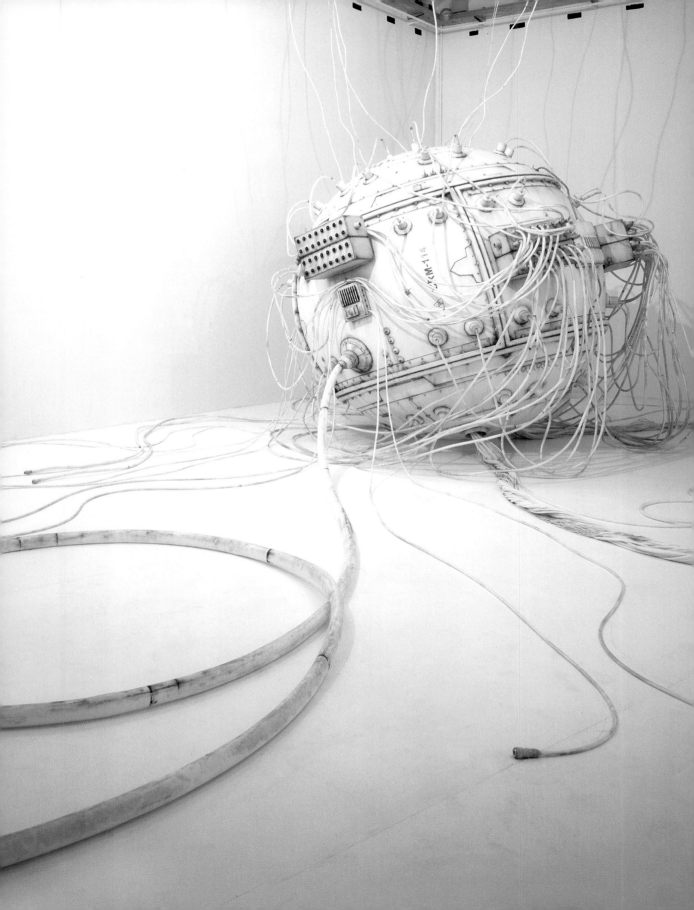

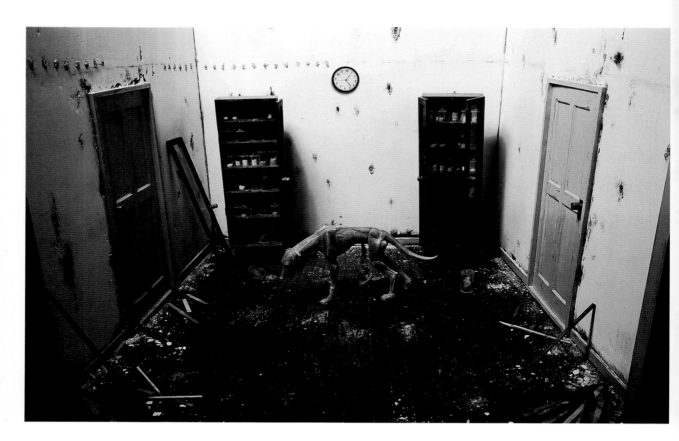

THIS PAGE, TOP: *Jackal* (still), 2005. Laser print, one half of diptych, 20½ x 32 in.

THIS PAGE, BOTTOM: *Rompers* (still), 2003. Digital effect c-print mounted on aluminum, 31½ x 26 in.

FACING PAGE: *9th Room* (installation), 2001. 4 DVDs, 4 DVD decks, 4 screens, mirrors, 4 speakers, other media. Approx 126 x 126 x 126 in.

Takashi Okazaki

Born 1974, Kanagawa Prefecture

Since graduating from the Faculty of Art and Design of Tama Art University with a degree in sculpture, Takashi Okazaki has been active in the fields of graphic design, illustration, and manga. He worked with film director Katsuyuki Motohiro on the concept design for the movie *Space Travelers* (2000) and on character design for the same director's phenomenally successful *Odoru daisosasen the movie 2* (Bayside Shakedown 2), which became the highest grossing non-English language film of 2003.

In 1998 Okazaki started an edgy, small independent manga magazine *Nou Nou Hou* with his brother Dai Okazaki—a performance artist who goes by the name of Smelly—and illustrator Imaitoonz. It was in *Nou*

Nou Hou that Okazaki first published his manga *Afrosamurai*, the bloody and violent story of one man's quest to avenge the death of his father which he witnessed as a child. Despite its underground beginnings in a self-published magazine with a circulation of only a few hundred, *Afrosamurai*'s bold brushstrokes, striking cubic composition, and dynamic energy—swords, afro hair, and flying headbands spilling out of every frame—made a strong impression, and eventually Okazaki was approached with requests to allow the story to be made into a television anime version and a live-action feature film for American audiences, both featuring Hollywood star Samuel L. Jackson in the title role and as coproducer. It seems that Takashi Okazaki will be remembered more for his contribution to the world of anime and movies than for his amazing talent as an artist.

THIS PAGE, TOP: *Afro*, 2003. Indian ink and digital color on Kent paper.

THIS PAGE, BOTTOM: *Shikaku 2*, 2002. Indian ink and digital color on Kent paper.

FACING PAGE: *Afro 2*, 2002. Indian ink and digital color on Kent paper.

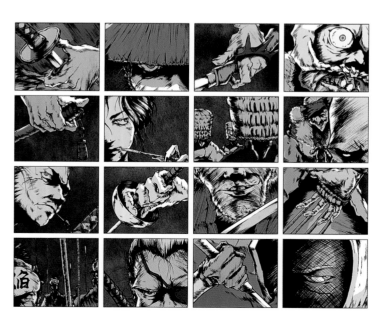

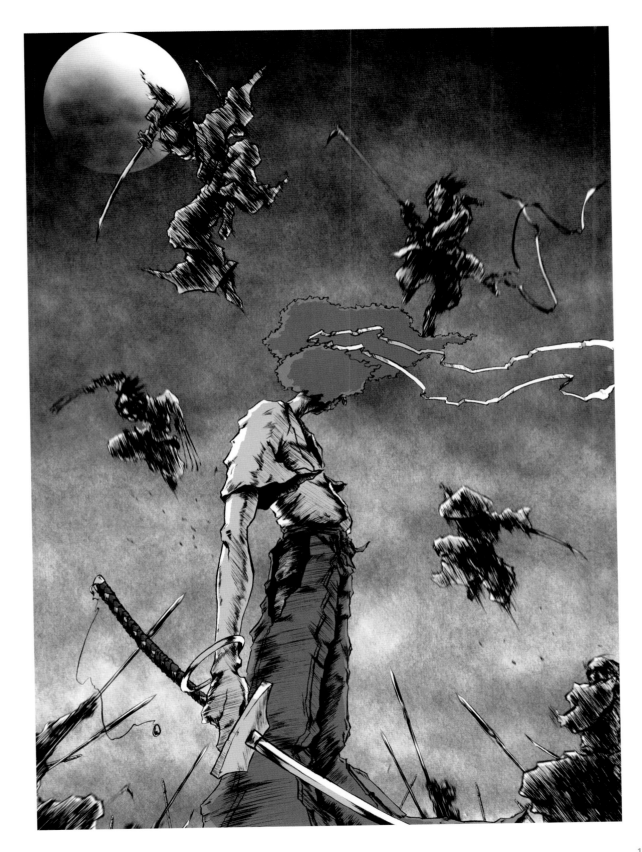

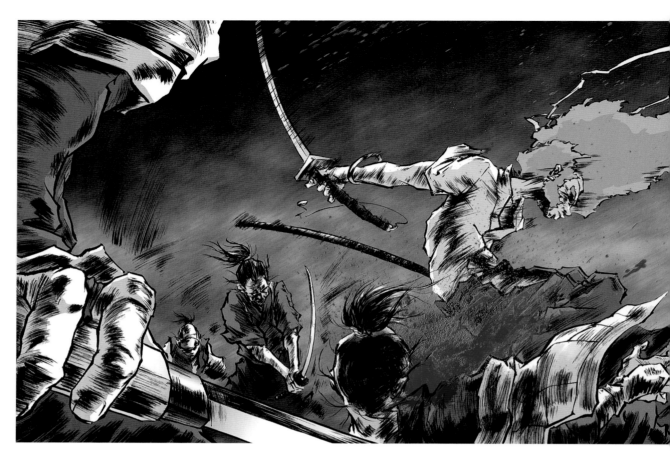

TOP: *The Battle*, 2006. Indian ink and digital color on Kent paper.

BOTTOM: *Shikaku 1*, 2002. Indian ink and digital color on Kent paper.

Tomoko Sawada

Born 1977, Kobe

Tomoko Sawada's work consists of photographs of herself in many different guises, and her basic theme is the relationship between the inner woman and her outward appearance. Since her debut exhibition in 1997, she is gradually making a name for herself on the world stage, with works such as *ID400* (1998), in which she dresses as four hundred different women and poses for black-and-white photo booth self-portraits. In *cover* (2002), she imitates the fashions peculiar to the tribe of teenage girls whose stamping ground is Tokyo's Shibuya district, a comment perhaps on the covering up of individuality that takes place when teenage girls band together to follow a particular style.

The 2004 *School Days* series uses the vehicle of the class photograph to explore issues of identity. In ten different class photos, Sawada styles herself as hundreds of different girls and ten different teachers to show how subtle differences in hairstyle or skirt length can be statements of individuality in a strictly regimented environment.

Sawada's inspiration for *Costume* (2003–2004) came from her experiences working for a temp agency, when people's reaction toward her would change according to her job. In guises as varied as policewoman, receptionist, or bar hostess, Sawada forces us to question the assumptions we make about women based on their appearance.

BELOW: *cover (B)*, 2002. C-type print, 35½ x 84½ in.

FACING PAGE: *cover (11)*, 2002. C-type print, 35½ x 39 in.

125

FACING PAGE, TOP: *School Days/A*, 2004. C-type print, 7½ x 9½ in.

FACING PAGE, BOTTOM: *School Days/B*, 2004. C-type print, 7½ x 9½ in.

THIS PAGE, TOP: *Costume/KANGOFU (Nurse)*, 2004. C-type print, 39 x 31½ in.

THIS PAGE, BOTTOM: *Costume/OHANAYASAN (Florist)*, 2004. C-type print, 31½ x 39 in.

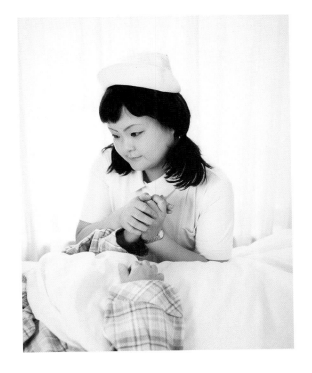

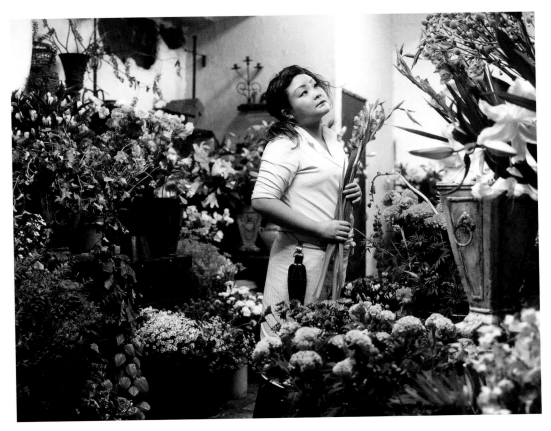

Ryoko Suzuki

Born 1970, Sapporo

Ryoko Suzuki's series *Anikora* refers to the Internet craze for photo-collaging the faces of famous women onto the bodies of nudes, known as *aikora* in Japanese, short for *aidoru koraju*, or, in English, idol collage. This phenomenon was born of men's desire to see their favorite stars pose naked.

Suzuki's *Anikora* manages to deftly sidestep such masculine desires. The nudes featured have the unbelievably perfect bodies of anime characters, but the face collaged on to the torso is that of Suzuki herself. The work has a sensational aspect; we are seeing the artist "nude," but it is also an ironic glance toward women who strive for the ultimate cosmetic beauty, and toward the growing numbers of geeky *otaku*

men who are attracted to the virtual bodies of anime characters. There is a word *moe* in Japanese, recently coined to describe this vague libidinous impulse directed at a fictional female character by a male otaku.

Suzuki's unrealistic *Anikora* nudes, lacking pubic hair and with breasts that are often without nipples, contrast strongly with the imperfect bodies depicted in her *Human Being* series. But the stark, monochrome portraits of real people have a warmth that does not exist in the perfect world of the idol collage.

In *Mama Doll*, Suzuki superimposes a photograph of a mother's face over a photograph of the face of her son or daughter, merging two distinct yet intimately related individuals into one evocative image. The father's face is absent, a comment on the Japanese family system, where fathers are expected to work long hours and often spend little time with the family, and mothers have sole responsibility for child rearing.

THIS PAGE: Left, *Ritsuko-Takumi*, 2004. Lambda print, 59 x 47 in. Center, *Yuko-Tatsuya*, 2004. Lambda print, 59 x 47 in. Right, *Akemi-Azusa*, 2003. Lambda print, 59 x 47 in. All from the series *Mama Doll*.

FACING PAGE: *Sweat 3*, 2002, from the series *Anikora*. Lambda print, 90½ x 47 in.

FACING PAGE: *Sweat 7*, 2002, from the series *Anikora*. Lambda print, 90½ x 47 in.

THIS PAGE, TOP LEFT, BOTTOM LEFT, TOP RIGHT: *Human Being*, 2006. Gelatin silver print, 35½ x 35½ in.

THIS PAGE, BOTTOM RIGHT: *Human Being*, 2006. Gelatin silver print, 71 x 43 in.

Tabaimo

Born 1975, Hyogo Prefecture

Tabaimo rose to prominence on the back of her graduation production *Japanese Kitchen*, a video installation that took the Grand Prize at the Kirin Contemporary Award in 1999 when she was twenty-four years old. She was made a professor at her alma mater, Kyoto University of Art and Design, while still in her twenties, an unusual career trajectory for such a young artist in Japan. Tabaimo's work has attracted a great deal of attention both in Japan and overseas, and she has exhibited all over the world.

Tabaimo makes the most of modern technology, utilizing computers extensively in her work to create very intricate installations featuring moving images, but her setting is often a nostalgic Japan replete with traditional elements that include Japanese dinner tables, paper screens, and sliding doors in wooden houses. She uses strong pen lines, and colors reminiscent of the *ukiyo-e* style of traditional Japanese woodblock prints, and the resulting image evokes the *gekiga* comics of the 1960s and 70s, which had more sophisticated storylines and less cartoonish drawings than regular manga. Her themes involve gruesome and creepy murders and juvenile crime, and the various strange, dark events that invade our living rooms via the media. In *Haunted House*, a family eat dinner on the inside of a cramped city apartment, while on the outside a suicide takes place.

THIS PAGE: *Image for midnight sea*, 2006. Video installation.

FACING PAGE, TOP: *Japanese Kitchen*, 1999. Video installation.

FACING PAGE, BOTTOM: *Haunted House* (still), 2003. Video installation.

In the video installation *public conVENience* that featured in her widely acclaimed 2006 solo exhibition Yoroyoron at Tokyo's Hara Museum, Tabaimo shows women doing their best to ignore each other as they go about their private business in a public toilet. But this is no ordinary public space: one woman is attacked by her reflection as she stands in front of the mirror. Another woman tries to flush a turtle down the toilet. "A public toilet is like the Internet," says Tabaimo. "These facilities are open to everyone, but essentially each is an exclusive space. So many things happen behind the thin walls that separate us, including crimes."

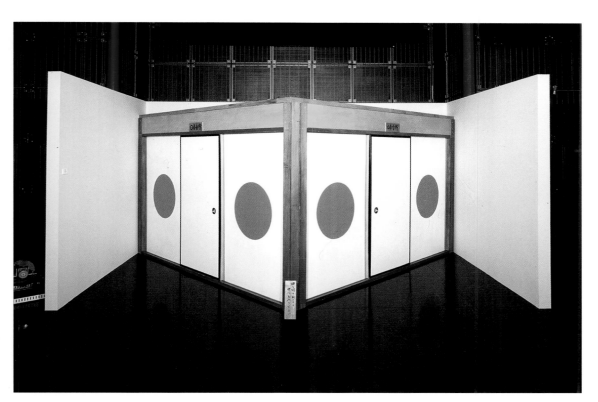

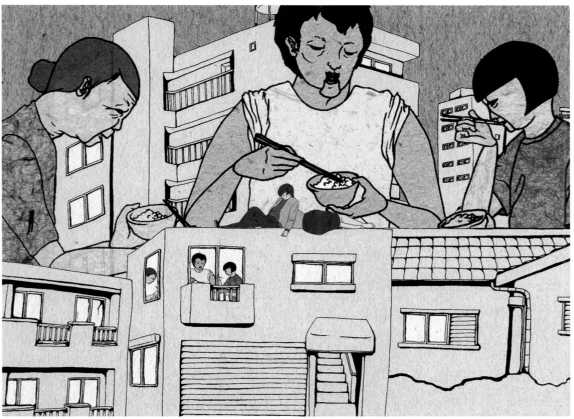

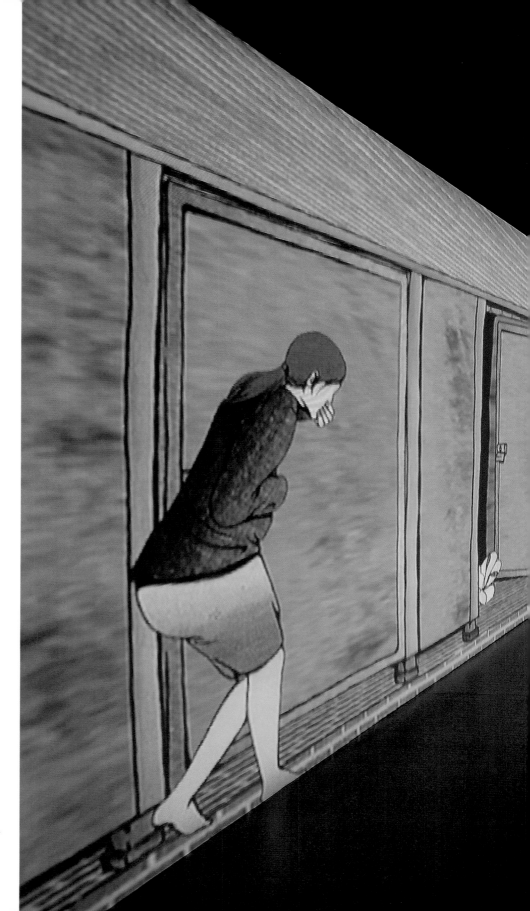

public conVENience, 2006.
Video installation.

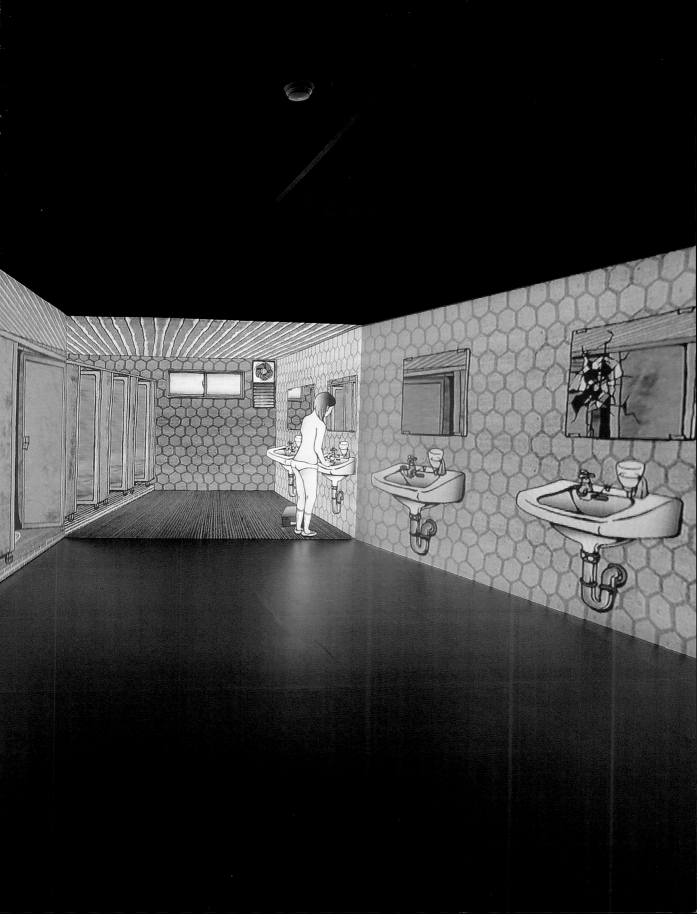

Iichiro Tanaka

Born 1974, Aichi Prefecture

Baseball players come in two types: those who work hard to attain skill and technique, and those who are simply blessed with an extraordinary talent. Artists are the same, and without a doubt Iichiro Tanaka belongs in the second group. These geniuses come with three hallmarks: they surprise people, they make people think, and they make people laugh, as in *Street Destroyer*, for example, where Tanaka casts himself as the person responsible for the everyday destruction and dereliction that is a regular feature of Tokyo's streets.

Drop-eyed DARUMA features the traditional lucky Japanese daruma doll. Sold with blank eyes, the owner colors in one eye while making a wish. When the wish comes true, the owner colors in the other eye. In Tanaka's work, both colored-in eyes have dropped out, making us chuckle as we ponder what fate befell the maker of the wish.

In 1980s Japan, the television anime *Mobile Suit Gundam* was very popular with children, especially boys, who would enjoy assembling and painting plastic figures of characters from the series. Tanaka's *GUNDAM: A Slip of the Face* replicates a child's clumsy attempt to paint one of these figures. This time our laughter is tinged with nostalgia as we remember the smells and ambience of childhood, of playing outside right into dusk, and the sudden sense of desolation when we realize that the day is over and it is time to go home.

Street Destroyer, (Property 001), 2004.
C-print, 9½ x 15 in.

THIS PAGE, TOP: *Street Destroyer (Property 003)*, 2004.
C-print, 3 x 3 in.

THIS PAGE, CENTER: *Street Destroyer (Property 004)*,
2004. C-print, 3 x 3 in.

THIS PAGE, BOTTOM: *Street Destroyer (Property 002)*,
2004. C-print, 3 x 3 in.

FACING PAGE, TOP: *Drop-eyed DARUMA*, 2002. Mixed
media, dimensions variable.

FACING PAGE, BOTTOM: *GUNDAM: A Slip of the Face*,
2002. Mixed media, 1¼ x 1¼ x 1 in.

138

Hisashi Tenmyouya

Born 1966, Tokyo

THIS PAGE: *Nine-tailed Fox,* 2004. Acrylic on wood, 59 x 47 in.

FACING PAGE: *Contemporary Japanese Youth Culture Scroll "Kamakura Nine Samurai,"* 2001. Acrylic on wood, 23½ x 16½ in.

Hisashi Tenmyouya draws on the themes and style of traditional *nihonga* painting, but instead of the mineral pigment paints common to this genre, he works with acrylic paints, and incorporates street-culture elements such as graffiti and tattoos into his pieces. In this way, he could be said to be giving his own twist to the ancient Japanese literary tradition of *honkadori*, where an allusion from an earlier well-known poem is incorporated into a new poem. His work can also be seen as playfully subverting some of the ste-reotypical images of traditional Japan often held by foreigners. Tenmyouya has referred to his own style as "neo-nihonga."

Tenmyouya's sophisticated grasp of both the ancient and the contemporary has led him to be described as a "punk samurai" by some critics. His love and in-depth knowledge of the traditional warrior paintings known as *musha-e* is evident in his work. The flamboyantly dressed warriors who feature in many of Tenmyouya's paintings evoke the fashions of *basara* from the fourteenth century, and *kabukimono* from the end of the sixteenth century, when men would compete for a sense of style with outrageous clothes and wild behavior. But the warriors depicted in works such as *Kamakura Nine Samurai* from his *Contemporary Japanese Youth Culture Scroll* series are of the hip-hop variety, break-dancing and spray-painting graffiti on Buddha's statue.

Tenmyouya's work appeals to both serious art critics, and to a young "street" audience, and his fame is rapidly spreading. He was one of fifteen artists worldwide selected to represent their country's soccer team in the Official Art Poster 2006 FIFA World Cup Germany™ project, and to coincide with this event a documentary film about the artist, *Near Equal-Tenmyouya Hisashi,* directed by Go Ishizaki, was released in Japanese cinemas.

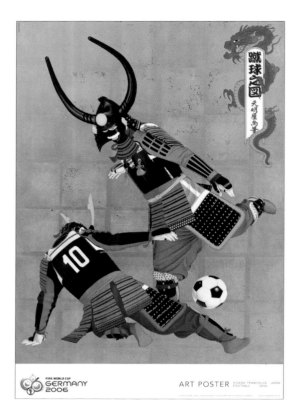

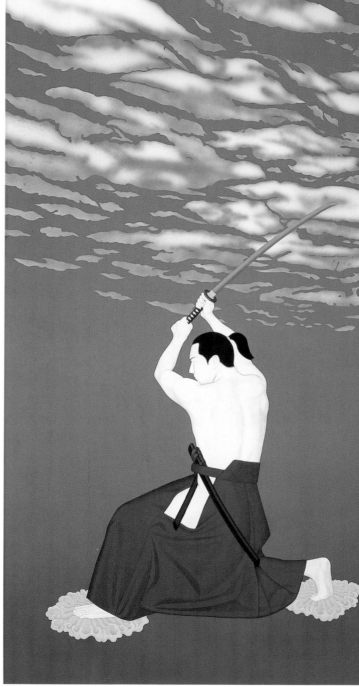

ABOVE: *Hisashi Tenmyouya, Football 2004, Japan,* © 2005 FIFA.

RIGHT: *Bunshin,* 2005. Acrylic on wood, 57 x 79 in.

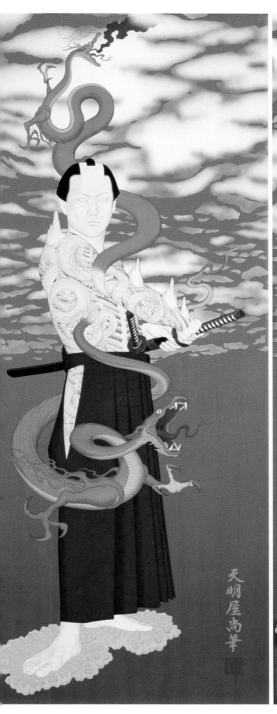
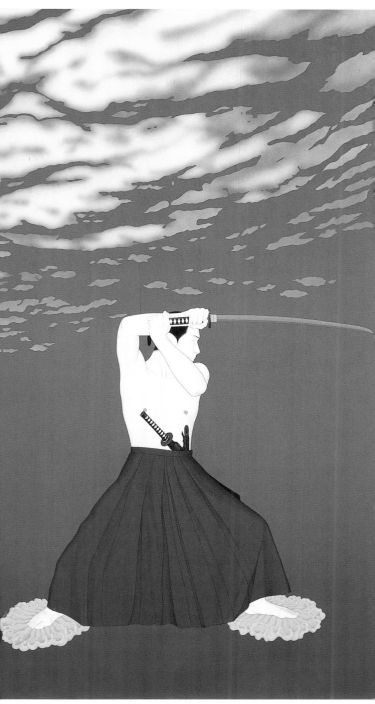

Toast Girl

Born Melbourne, Australia

Back in 1998, in a kitchen somewhere in Melbourne, Australia, a Japanese exchange student, feeling bored, decided to toast a piece of bread while holding the toaster on her head. The performance artist known as Toast Girl was born. At her debut performance in Melbourne, she made toast on her head while her friend's band played. The success of this act inspired her to carry on working as a performance artist back in Japan. In her stage shows, Toast Girl sings and dances, dressed in a cute pink dress and pinafore. Props include a toaster attached to the red workman's helmet on her head, and roller-skate vacuum cleaners on her feet.

Toast Girl's emergence as a manga-like character come-to-life coincides with the cosplay trend in Japan, where people enjoy dressing as their favorite anime or manga characters. It can also be seen as part of a wider trend in the arts and entertainment world, comparable to Vanessa Beecroft's performance works in which live models are given instructions on their poses, or to the UK rock group Gorillaz, who have turned their members into cartoon characters. Toast Girl's singing, dancing, and simple props are very far from the realm of high art, but she has a strong following among young women in Japan who find something appealing in the playful freedom of her stage persona and in her lighthearted subversion of the items of domestic drudgery.

THIS PAGE, TOP: Toast Girl at the window, 2004.

THIS PAGE, BOTTOM: Toast Girl puts on her vacuum cleaners, 2001.

FACING PAGE, TOP: *Supersucker*, 2001.

FACING PAGE, BOTTOM: *Supersucker New*, 2001.

THIS PAGE: Toast Girl live on stage at 8 Hall, Kanazawa, 2004.
FACING PAGE: *Tokyo*, 2004.

Noboru Tsubaki

Born 1953, Kyoto

Noboru Tsubaki is more than just an artist: he is also an educator and activist whose art encourages the public to consider questions of social and political importance. His *UN Boy* project, first exhibited in 2003, forces us to reconsider what the terms "peace" and "peacekeeping" really mean. The exhibition begins with a press briefing room dominated by a distorted UN logo in which the map of the globe has been turned upside down, and where the olive branches no longer embrace the globe protectively but spread out from it like wings. One wall is decorated with replicas of the regulation assault rifles that are standard issue for the so-called peacekeeping forces of the United Nations. Fixed into place and thus rendered useless, an alarm buzzer is triggered if viewers come too close.

Part of the same project are the robotic sculptures *TETSUO*, an adorable teddy-bear shaped robot for processing depleted uranium, and *PENTA*, a landmine removal robot that is unable to move, trapped in a room where the walls are decorated with images of landmine seals. When we reflect on the fact that some landmines are actually designed to resemble toys, the fiction unfolding in the exhibition space is suddenly not so far moved from reality.

Another politically motivated installation is *Cochineal*, a large fiberglass insect that invites visitors into the "web" in which it is housed. The insect is the embodiment of a computer virus. Visitors wear sensors that allow them to physically feel the attack of the virus on their skin. They can kill the insect by pushing a button, but this also results in making other insects appear. The piece is a warning about the dangers of cyberterrorism, and our tendency to accept the advance of new technology without stopping to consider its long-term implications.

THIS PAGE: *Code name "Cochineal"— UNapplication No.13*, 2003. FRP, 35½ x 47 x 82½ in.
FACING PAGE, TOP: *UNa Showcase*. Installation, Art Tower Mito, 2003.
FACING PAGE, BOTTOM: *Code name "ATTA"— UNapplication No.1*, 2003. Digital.

THIS PAGE, TOP: *UNa_anagram*, 2003, adhesion seal.

THIS PAGE, BOTTOM: *Code name "PENTA"—UNapplication No.1*, 2003. Aluminum, projector, network, 162 x 126½ x 126½ in.

FACING PAGE, TOP: *Code name "TETSUO"—UNapplication No.3*, 2003. Foaming urethane, conveyor belt, sound system, 216½ x 177 x 149½ in.

FACING PAGE, BOTTOM: *Code name "UN application"—UNapplication No.0*, 2003. Model gun, logo mark.

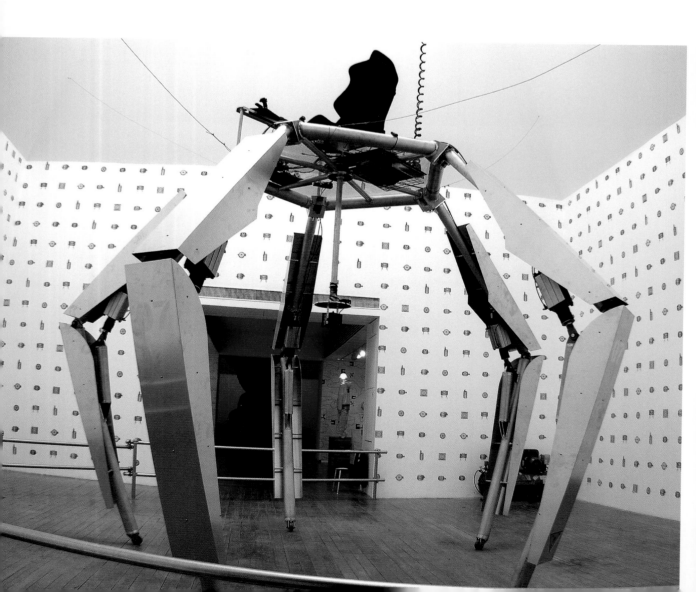

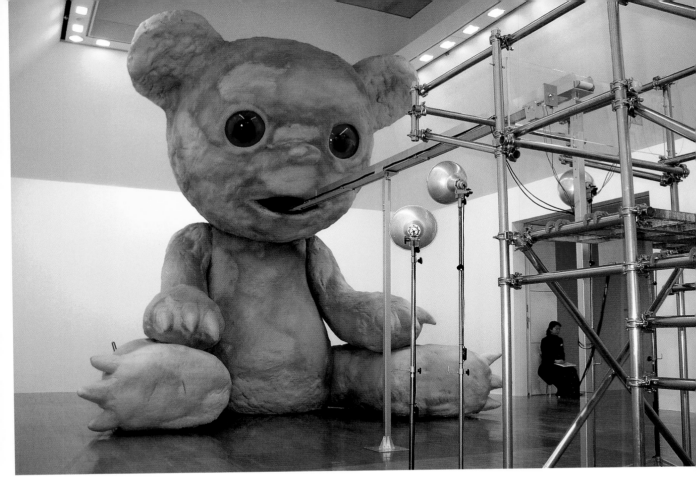

Ai Yamaguchi

Born 1977, Tokyo

The characters who feature predominantly in Ai Yamaguchi's work are a group of prepubescent nine- and ten-year-old girls who work as servants in a fictional courtesans' house called *Toge-no-ochaya*, which translates as The Teahouse of the Mountain Pass. The narrative is set at some unspecified time in the Edo period (1603–1868), and the paintings combine a manga sensibility with the style of traditional *ukiyo-e* woodblock prints.

Child courtesans actually existed in the Edo period, but rather than reflect on the misfortune of the group of nine girls or on the debauchery of their surroundings, Yamaguchi concentrates on the simple daily details of their lives as they relax and play against a backdrop of changing seasons. The flow of the simple curved lines she uses to delineate the girls' bodies, the exquisite traditional patterns printed on the cloth of their kimonos, and the colorful nature that surrounds the girls combine to give her work a seductive beauty that has attracted a broad fan base. In Japan she is particularly popular with young women, and there is even a line of traditional sweets decorated with the images of the nine young courtesans available in the confectionary shops of Tokyo's upscale shopping districts.

Yamaguchi has exhibited widely in group and solo shows in Japan and also in the United States, where she is popular with fans of anime and manga. She has also taken part in a collaboration with world-famous Japanese makeup artist Shu Uemura, who used her artwork on the packaging for his cosmetics.

THIS PAGE, TOP: *Tebana: haru*, 2005. Acrylic on cotton, diameter 7 in. x depth 2 in.

THIS PAGE, BOTTOM: *Omoudochi*, 2005. Acrylic on clam shell, 35½ x 25½ x 6 in.

FACING PAGE, TOP LEFT: *Kai soshite watashi wa*, 2003. Acrylic on wood, 17½ x 23 x 1½ in.

FACING PAGE, TOP RIGHT: *Hyaku no hana, yuki wa furitsutsu*, 2004. Acrylic on wood, 25 x 29 x 3 in.

FACING PAGE, BOTTOM: *Dokkoi*, 2004. Acrylic on handmade paper, 45 x 63 in

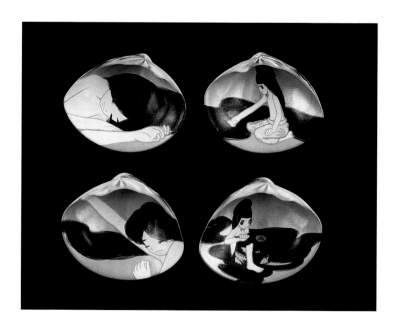

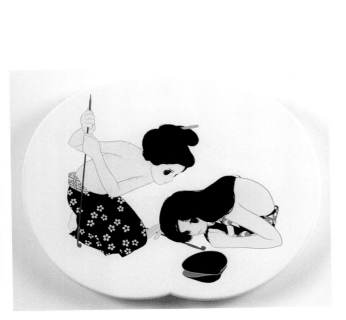

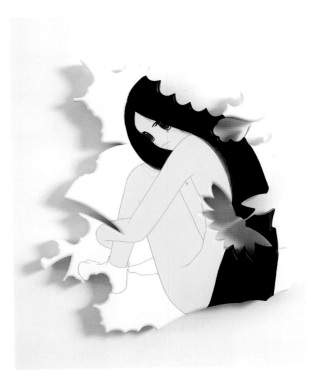

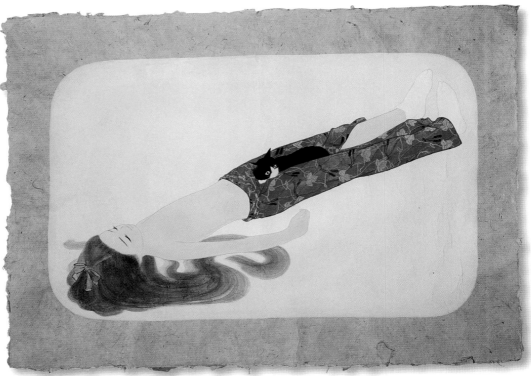

OVERLEAF: *Kinuginu.* Acrylic on wall,
185 x 165 x 98½ in. Installation
view, Gallery Eve, Tokyo, 2002.

153

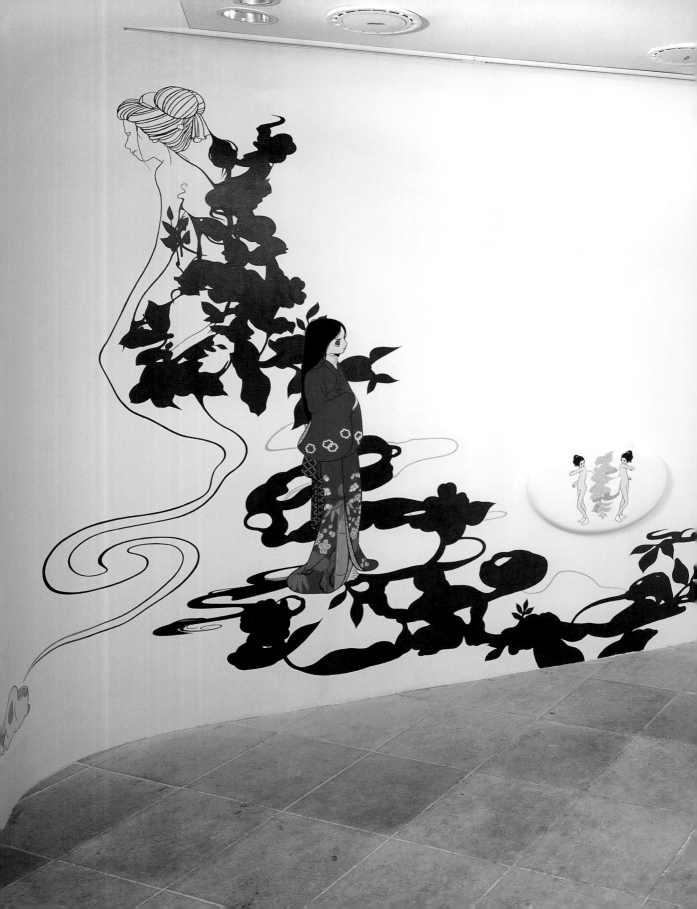

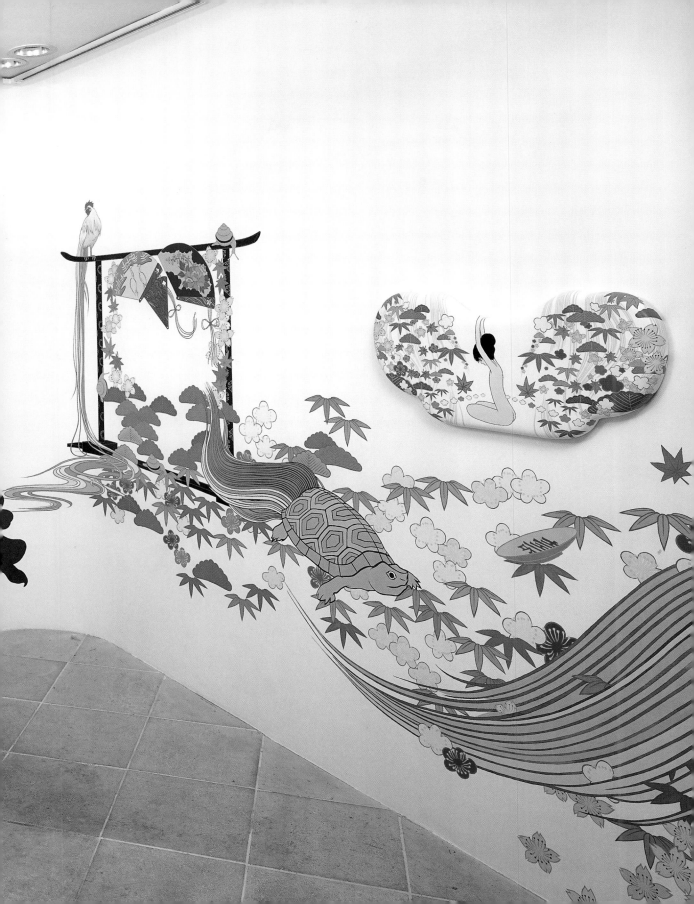

Akira Yamaguchi

Born 1969, Tokyo

At first glance, the works of Akira Yamaguchi resemble the classical Japanese paintings known as *yamato-e*, a style that dates from the Heian period (794–1185) and is characterized by scenes of native landscapes, seasonal references, and flat planes of vivid color. On closer inspection, however, we see that Yamaguchi's paintings are crowded with a mix of people and buildings from a variety of eras, from the present, to the Edo period (1603–1868), to the Sengoku period (1467–1603). These disparate elements seem to overcome the limitations of time and space, melding smoothly together to present us with a Japanese landscape that has a truly contemporary feel.

The golden clouds that float through Yamaguchi's landscapes are like those that appear in Japan's sixteenth and seventeenth century folding screen paintings known as *rakuchu rakugai zu*. His use of buildings without roofs seen from an overhead perspective is a reference to a *yamato-e* compositional device known as *fukinuki yatai* (room with roof blown away). But there are futuristic machines and buildings in his work that could come from a science fiction manga. This mix of old and new could be interpreted as a lament for traditional Japanese values in a culture that is increasingly Westernized, but it is Yamaguchi's humor in juxtaposing these elements that makes the strongest impression on the viewer.

FACING PAGE, TOP: *Construction of Shiba Tower* (detail).

FACING PAGE, BOTTOM: *Construction of Shiba Tower*, 2005. Oil and watercolor on canvas, 39 x 150 in.

THIS PAGE, TOP: *Horse Stable*, 2001. Oil on canvas, 29 x 69 in.

Noriko Yamaguchi

Born 1983, Osaka

The works of Noriko Yamaguchi, in which the artist undergoes various eerie metamorphoses, remind us of science fiction movies such as *Tetsuo* or *Terminator*. In the series *Princess Ogurara*, Yamaguchi is photographed covered with azuki beans in such a way that it looks as though the beans are corroding her. "One of my themes is the feeling of the skin as experienced from the eye's perspective," she says. "I express this through various materials that are worn or put onto the body." In the *Golden Zazame* series, she covers herself in thumbtacks, evoking a sensory pain in the viewer, which in turn, she tells us, allows her to "empathize with the tack."

In the *Keitai Girl* series, Yamaguchi wears a bodysuit made of cellphone keypads, a comment on today's society where people live in cyberspace and have less and less physical interaction with others. Her bodysuit suggests both a desire to be touched and a lust for physical communication.

Yamaguchi took part in Boston's SIGGRAPH2006 Fashion Show, where she directed a performance by two keitai girls dancing ParaPara (a style of club dancing popular with teenage girls in Japan) to Eurobeat music.

"Keitai Girl is a metaphor for the Asian woman," explains Yamaguchi. "It's important that she talks to the West through her mobile phone."

Keitai Girl No. 4, 2004. Color photograph, 34 x 47 in.

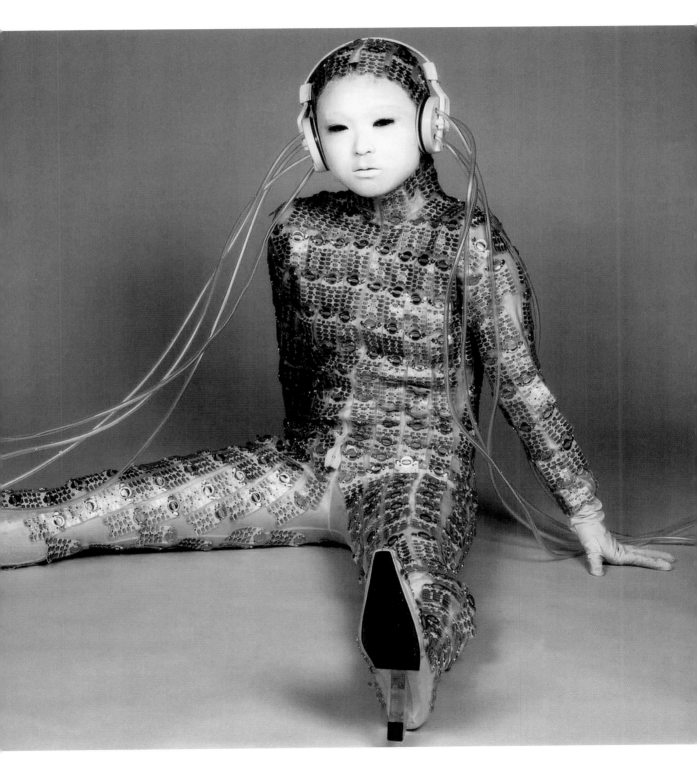

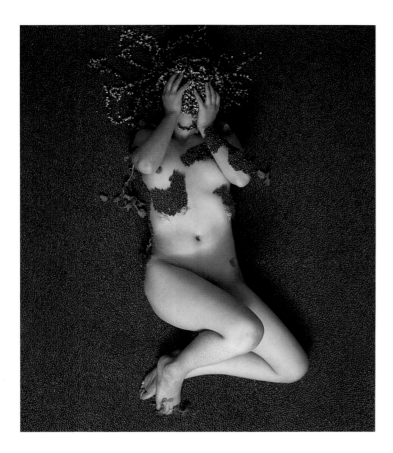

THIS PAGE, TOP: *Princess Ogurara No. 5*, 2005. Color photograph, 54 x 45 in.

THIS PAGE, BOTTOM: *Princess Ogurara No. 2*, 2005. Color photograph, 37 x 47 in.

FACING PAGE: *Golden Zazame No. 10*, 2005. C-print, 47 x 47 in.

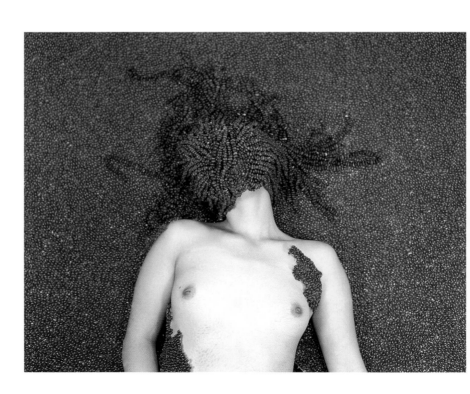

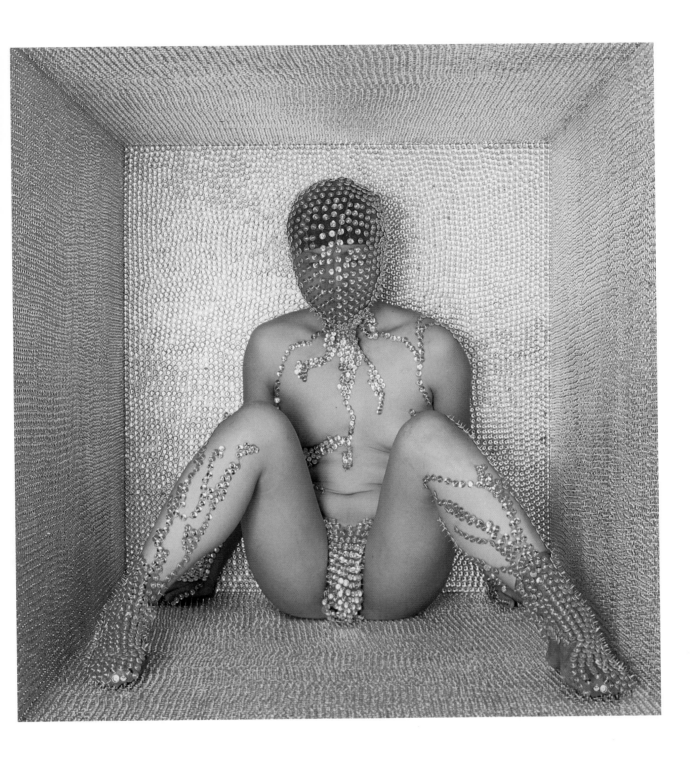

Miwa Yanagi

Born 1967, Kobe

Miwa Yanagi is one of the most outstanding Japanese artists working in the fields of photography and video today, and her major theme relates to the role of women in society. Her early series *Elevator Girl* features that unique occupation for women in Japan. The confined space in which the uniformed elevator girl repeats the same words and gestures every day seems to be a metaphor for restrictions that society places on women's behavior. In the *My Grandmothers* series, Yanagi asked a selection of young women to imagine their lives in fifty years time, when they might be free of societal pressures to conform, and can do anything they want. She deliberately chose the most unconventional replies (there are no happily married grandmothers surrounded by family in this series), and photographed the women in these imagined roles, using computer technology to age their faces.

In the 2004 *Fairy Tale Series*, Yanagi continues to explore the theme of female identity by photographing scenes based on well-known stories that feature young girls and old women, such as those found in *Grimm's Fairy Tales*, or in the more contemporary *The Incredible and Sad Story of the Candid Erendira and her Heartless Grandmother* by Gabriel Garcia Marquez. An untitled work from this series shows a woman wearing a structure much like a circus tent on her head. Her legs are those of a young girl, but her hands are those of an old woman, and she seems to be trying to find a way out from the darkness inside the tent to the brighter outside world. The mysterious figure is at once a gateway between the fairytale world and the audience, between the photographer and her subject, and between the young girl and the old woman.

THIS PAGE, TOP: *Fairy Tale Series: Untitled 1,* 2004. Gelatin silver print, 55 x 39½ in.

THIS PAGE, BOTTOM: *Elevator Girl House B4,* 1998. C-print, 78½ x 94½ in.

FACING PAGE: *Fairy Tale Series: Erendira,* 2004. Gelatin silver print, 39½ x 39½ in.

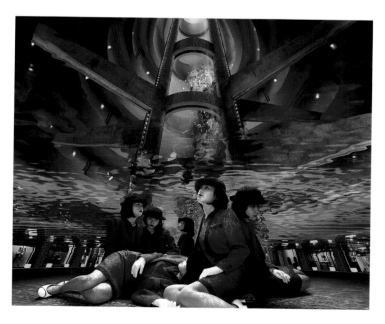

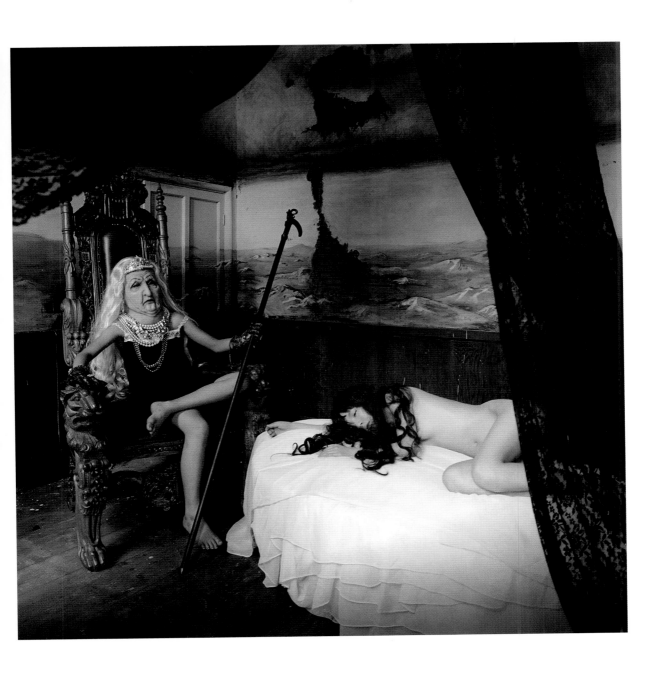

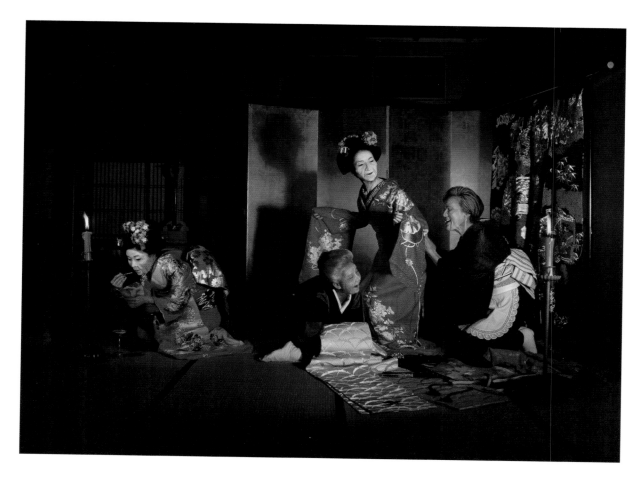

THIS PAGE, TOP: *My Grandmothers/Geisha (Akiyo/Mai/Hitomi/Noriko)*, 2002. LightJet print, 71 x 94½ in.

THIS PAGE, BOTTOM: *My Grandmothers/Minami*, 2000. LightJet print, 52½ x 63 in.

FACING PAGE: *My Grandmothers/Miwa*, 2000. LightJet print, 39½ x 47 in.

Kenji Yanobe

Born 1965, Osaka

Kenji Yanobe's work deals with the theme of survival after nuclear holocaust. In his *Atom Suit Project* series he is photographed wearing his own survival suit, equipped with a Geiger counter, in locations such as Chernobyl and the remains of the site of the 1970 Osaka World Expo, near the place where he grew up. As a young boy, he witnessed what he calls "the ruins of the future," when the Expo ended and the futuristic pavilions were pulled down.

Yanobe's "atom" suit takes its name from the Japanese anime character Astro Boy (known as *Tetsuwan Atomu* in Japanese). Another of his works, *Foot Soldier* (*Godzilla*), is a model of a kind of personal combat vehicle where the controller sits atop a pair of giant Godzilla-style legs. Both Astro Boy, an atomic-powered robot, and Godzilla, born from hydrogen bomb experiments, feature nuclear power as their common denominator, a continuing reflection of Yanobe's preoccupation with this theme. It is no coincidence that both Astro Boy and Godzilla are characters popular with Japanese children, for this is an audience Yanobe specifically targets, in the belief that it is children who carry our hopes for the future. His work *Cinema in the Woods* consists of a child-sized survival suit and a cinema that only admits kids. *Giant Torayan* is an interactive robot that breathes terrifying flames in response to shouted instructions from children.

THIS PAGE: *Viva Riva Project: New Deme*, 2002. Steel, motor, water, other media, 199 x 145 x 118 in.

FACING PAGE, TOP: *Giant Torayan*, 2005. Aluminum, steel, brass, FRP, Styrofoam, 283 x 181 x 122 in.

FACING PAGE, BOTTOM: *Cinema in the Woods*, 2004. Mixed media, 90 x 86 x 50 in.

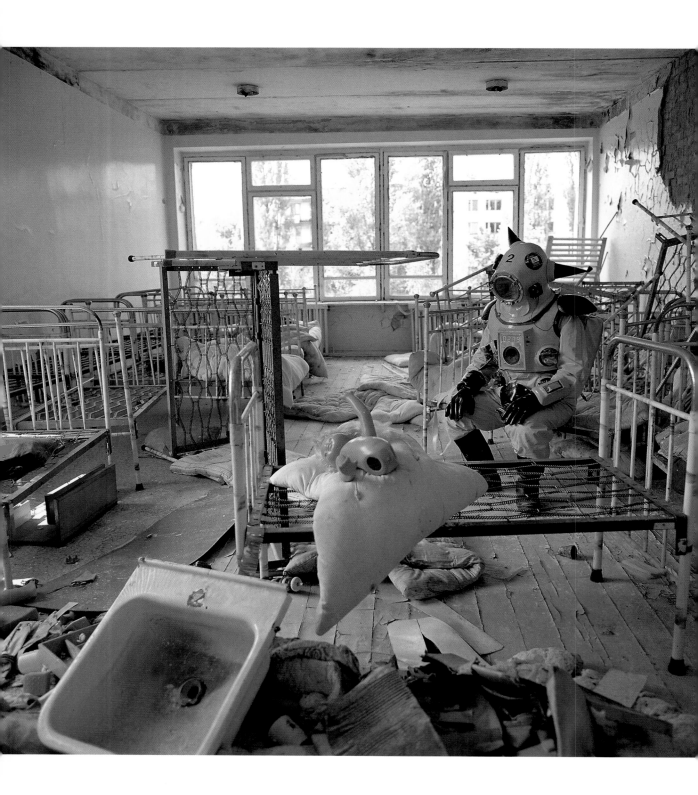

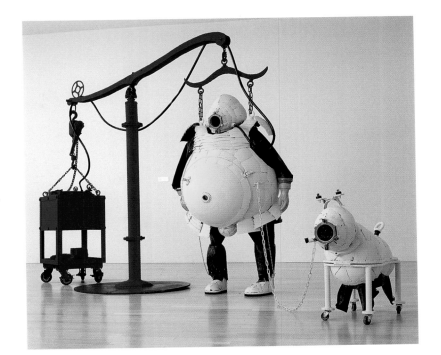

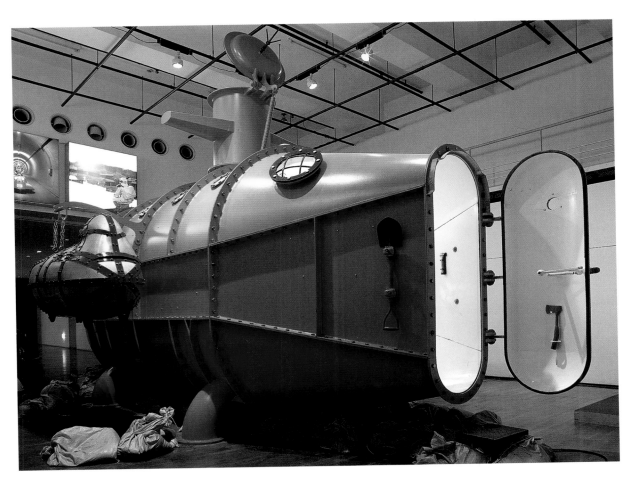

FACING PAGE: *Atom Suit Project: Nursery School 1, Chernobyl*, 1997. Light box, 47 x 47 x 47 in.

THIS PAGE, TOP: *Yellow Suit*, 1991. Lead, steel, plants, Geiger counter, 90 x 118 x 118 in.

THIS PAGE, BOTTOM: *Bunker Bunker*, 1998. Steel, oxygen, food, water, others, 157 x 157 x 236 in.

Glossary

Bushido: A term to describe the ethical code of Japan's samurai warriors, a code that valued honor above life

gofun: A white pigment made from the ground shells of oysters and clams

kimo-kawaii: A Japanese word that combines the terms *kawaii* (cute) and *kimochiwarui* (disgusting) to describe something that is has both cute and disgusting qualities. A popular word with younger Japanese people.

kumohadamashi: Thick, traditional Japanese paper mixed with fiber such as linen

maid café: A café that caters to the otaku crowd, where waitresses dress as maids in the style of manga or anime characters

musha-e: Woodblock prints depicting warriors and battle scenes, popular between the late Edo period (1603–1868) and early Showa period (1925–1989)

nihonga: Painting that uses traditional Japanese conventions, materials, and techniques. This term came into use in the Meiji period (1868–1912) to distinguish Japanese-style painting from Western-style painting.

otaku: An obsessive fan of manga, anime, or other subculture

rakuchu rakugai zu: A form of painting popular between the sixteenth and eighteenth centuries in Japan, featuring views of Kyoto, typically from an aerial perspective, and usually on folding screens

rorikon: Short for "Lolita complex," this is a term that originated in Japan to describe an attraction to prepubescent girls, and is often used in the West (spelled "lolicon") to refer to the sexualization of young girls in manga and anime

samurai: A term for the elite warrior class that ruled Japan from the twelfth century until the Meiji period began in 1868

sento bishojo: a Japanese term that translates as "fighting beauty", and that refers to the beautiful teenage girls who take on the central heroic roles in anime and manga. Although male heroes of this genre have long been popular, the development of the "fighting beauty" genre has only become widespread since the 1980s.

Shintoism: Japan's ancient indigenous religion, characterized by ancestor worship and the worship of the deities of natural forces

sumi: Japanese ink used in calligraphy and painting, made of soot and glue, and hardened into stick form

superflat: A concept developed by Takashi Murakami in which he argues that all creative works on a flat surface are "hyper two-dimensional" or "superflat" and that this term can also be used to describe the shallow emptiness of Japanese consumer culture

torinoko: paper handmade from a species of mallow plant

ukiyo-e: A style of woodblock print that became popular in the Edo period, depicting landscapes or scenes from everyday life

yakuza: a word used to refer to members of traditional organized crime groups in Japan

yamato-e: A term that came into use around the ninth century to distinguish Japanese-style painting from Chinese-style painting

Photo Credits

Copyright for all images belongs to the respective artists except where otherwise stated.

Acknowledgments

First of all, I am grateful from the bottom of my heart to my editor, Cathy Layne, who gave me this opportunity to introduce Japanese artists to overseas readers. Her support and advice have been invaluable to me over the course of this project, and I feel very lucky to have met her. Thank you, Cathy!

I would like to thank Azby Brown who introduced me to Cathy Layne. Azby is the author of several wonderful books on Japanese architecture, and has extensive knowledge about contemporary Japanese culture. I feel that he and I are comrades, both eager to introduce Japanese culture to the world. I am also grateful to the City of Kanazawa, which brought Azby and I together as colleagues for the first time.

I cannot imagine how I would have made this book without the cooperation and understanding of the forty artists who took part. I would like to give my heartfelt thanks to the artists, galleries, and patrons who very kindly allowed us to show the wonderful works of art on display in this book. It is truly an honor for me to introduce overseas readers to these artists.

Great thanks are also due to Arthur Tanaka, who translated this book into English. I met him when I was living in Sydney. I feel sure there is no one better qualified for this task than Arthur, who is my friend and understands my activities in depth. But as he is a very talented movie producer, maybe I should stop asking him to do translation jobs for me!

Finally I would like to thank my family, who have constantly supported me throughout this project.

As for me, it is my intention to continue to devote my life to my self-appointed role as cheerleader for Japanese contemporary art.

And to the readers of this book . . . I hope that we will have the chance to meet one day, perhaps when we are standing side by side admiring one of the great works of art that exist on this earth.

（英文版）ウォリアーズ・オブ・ジャパニーズ・アート
Warriors of Art

2007 年2月26日　第 1 刷発行

著　者　　山口裕美
翻　訳　　アーサー田中
発行者　　富田 充
発行所　　講談社インターナショナル株式会社
　　　　　〒112-8652　東京都文京区音羽 1-17-14
　　　　　電話　03-3944-6493（編集部）
　　　　　　　　03-3944-6492（マーケティング部・業務部）
　　　　　ホームページ　www.kodansha-intl.com
印刷・製本所　　大日本印刷株式会社